ARTFUL LEADERSHIP

Indiana University Center on Philanthropy Series in Governance

James R. Wood and Dwight F. Burlingame, editors

ARTFUL LEADERSHIP

Managing Stakeholder Problems
in Nonprofit Arts Organizations

MARY TSCHIRHART

INDIANA UNIVERSITY PRESS

Bloomington and Indianapolis

The paper used in this publication meets the minimum requirements of American National Standard for Information Sciences--Permanence of Paper for Printed Library Materials, ANSI Z39.48-1984.

Manufactured in the United States of America

Library of Congress Cataloging-in-Publication Data

Tschirhart, Mary, date
 Artful leadership: managing stakeholder problems in nonprofit
arts organizations / Mary Tschirhart.
 p. c.m — (IU Center on Philanthropy series in governance)
 Includes bibliographical reference.
 ISBN 0-253-33234-6 (cloth : alk. paper)
 1. Arts—United States—Management. 2. Organizational
effectiveness. 3. Issues Management I. Title. II. Series.
NX765.T73 1996
700'.68—dc20 96-31852

1 2 3 4 5 01 00 99 98 97 96

For my parents, Irene and Philip Tschirhart

CONTENTS

Contents

PREFACE

We all have heard the phrase "you can't please everybody all the time." The subject of this book is how leaders of nonprofit arts organizations choose who gets pleased, when, and how. I look at the variety of problems that organizations experience with their stakeholders and the strategies that organizational leaders employ to manage these problems. Predictors of responses to problems are developed and tested, and themes in the problem-management process are identified. In analyzing the problem-management process, I provide insights into why problems with stakeholders arise and why specific responses are chosen and vary in their effectiveness.

This book is based on my dissertation work at the University of Michigan's Graduate School of Business Administration. The idea for the dissertation grew out of my experience as the executive director of a nonprofit arts organization. As the director, I was confronted with pressures to meet a variety of conflicting interests and expectations, while I simultaneously advanced my organization's interests and values. I developed a deep appreciation for the seemingly simple problems and more bewildering dilemmas facing nonprofit leaders as they deal with interacting and recurring pressures. My dissertation stemmed from my desire to see if there were patterned and predictable responses to problems with stakeholders. The study integrates and extends a variety of theories, with the most emphasis on building a model of problem management from resource dependence and institutional theory perspectives.

This book goes beyond the dissertation. To add greater understanding of the nonprofit context of the study, I returned to the original data and prepared new analyses examining specific stakeholder groups. I also pursued interesting avenues that were left unexplored in my desire to complete the dissertation requirement.

The conclusions drawn from the research suggest questions and techniques that can guide the crafting of problem-management strategies. The study's frameworks and models can help leaders see the assumptions, values, norms, and interests guiding their actions. Once underlying forces and issues are identified, leaders are better equipped to engage in thoughtful discussion and debate about appropriate responses to both the unique and more mundane problems they experience with stakeholders. Leaders may find that by exploring these forces and issues before a problem arises, the problem may be avoided or mitigated.

Although I hope the book is useful to practitioners willing to read about theories and statistical tests, the book's primary audience is students and scholars interested in nonprofit organizations. It holds special value for those wishing to learn more about management of arts organizations. I also hope the book will find a home with scholars interested in stakeholder management. The book elaborates problem management as an important component of stakeholder management.

Preface

The book maintains the basic format of a dissertation while filtering out the more esoteric statistical details and adding more examples to enrich the description of the findings. Chapter 1 presents the research questions and the frameworks differentiating types of problems with stakeholders and problem responses. Chapter 2 further develops understanding of the response strategies and predicts when the strategies will be used. Chapter 3 explains which predictions are supported, and adds some exploratory analyses of the consequences of the responses. Chapter 4 examines dynamics of problem management associated with particular stakeholder groups. Attention is focused on board members, staff, volunteers, patrons, contributors, and other arts organizations. Chapter 5 adds more pieces to the description of problem management. First, the deliberate and emergent nature of the problem management process is examined. Then the discussion moves to an exploration of leaders' goals and responsibilities and stakeholders' interests, legal rights, and moral claims. The chapter also presents a network perspective for understanding stakeholder management. The research methodology is described in Appendix A, along with details on the organizations studied. Appendixes B and C provide supplementary analyses.

This book would not have been possible without the assistance of a variety of individuals and institutions. My deepest gratitude goes to the executive directors and board members of arts organizations who agreed to be interviewed for the study. The project could not have been completed without their willingness and efforts to provide me with the information I requested. I respect them all for their dedication to their organizations and honesty in revealing weaknesses and failures as well as strengths and successes. The original research was partially funded by the Indiana University Center on Philanthropy through its Governance of Nonprofit Organizations Doctoral Dissertation Fellowships program. Additional funding was provided by the University of Michigan Graduate School and The School of Business Administration. The dissertation, and consequently this book, was improved through discussions with my dissertation committee: Professors Kim Cameron, Jane Dutton, Karl Weick, Tom D'Aunno, and Rick Bagozzi. As important stakeholders, my committee members' expectations and demands, though not always compatible, guided me through the dissertation project. The editorial talents of Lois Sherman and Brad Johns were instrumental in turning the dissertation into a much more readable book. My colleagues also helped with this transformation. Indiana University professors Janet Huettner and Jim Perry read portions of the manuscript. Professor Lynda St. Clair at the University of Michigan read the entire manuscript and, in addition to thoughtful editorial advice, offered good humor and unfailing encouragement. Coda endured my increasingly long absences from home as I worked to finish the book, greeting me with enthusiasm whenever I returned. This book is undoubtedly better for all their efforts.

ARTFUL LEADERSHIP

1

MANAGING RELATIONSHIPS
WITH STAKEHOLDERS

A substantial part of any organizational leader's job is "putting out fires." Managers routinely scan their environments, identify and analyze issues or problems, and respond. Issues and problems also may be identified, analyzed, and addressed by the governance bodies of organizations: the board of directors or trustees in nonprofit organizations, or the corporate board or owners in for-profit organizations. Many issues and problems are tied to an organization's relationship with its stakeholders, those actors inside or outside an organization who influence and/or are influenced by the organization (Freeman, 1984).

Skilled management of the interactions of organizations with their stakeholders may help organizations achieve their missions by reducing the negative effects of dissatisfied stakeholders and encouraging support from key stakeholders. An organization's stakeholders include its employees, volunteers, board members, funders, suppliers, clients/consumers, regulators, contractors, competitors, collaborators, and any other actors who have a stake in the organization's performance and/or the power to affect organizational performance. A stakeholder's claims or interests in an organization may be economic, legal, or moral. Examining how leaders interpret and manage problems with different types of stakeholders helps us understand why and how change occurs in organizations and organizational environments. Investigating the stakeholder-management process also helps us understand the varying pressures faced by leaders in stewarding their organizations' missions.

This book presents a model of problem management developed from my study of how leaders of nonprofit arts organizations manage problematic relationships with stakeholders. The leaders' organizations include theaters, symphony orchestras, arts centers, and arts councils. Analyses of the leaders' experiences show how nonprofit arts organizations maintain the legitimacy and flow of resources they need to survive and fulfill their missions. The leaders offer a variety of issues and problems their organizations experienced with stakeholders and their organizations' responses. The issues, problems, and responses vary in seriousness, complexity, duration, and management difficulty. They also differ in their potential consequences to the organizations and stakeholders involved.

Consider the case of a symphony orchestra struggling to attract audience members, a critical stakeholder group for an organization dependent on admissions for legitimacy and income. The director of one such organization told me that they were offering chamber music concerts despite board members' concern that the concerts were not attracting enough community interest to justify the expense. The concerts were offered to satisfy the artistic directors and some of the musicians, who wanted to perform more challenging works even though they played to almost empty houses.

Contrast this response with that of an arts museum, also struggling to attract audience members, which was criticized by a local church community for exhibiting "obscene" works. The church rented space in the center, and church members disapproved of paintings of male nudes that they passed on their way to church activities. The director of the center refused to remove the exhibit, recognizing this might result in future protests by church members and the loss of rental income. However, she did compromise by covering some of the offensive pieces on Sundays and strategically placing others so that they would not be visible to church members passing through the exhibition area.

Both cases reflect choices about organizational mission and the importance of satisfying different stakeholder groups. For the two cases, obvious stakeholders are the exhibits' target and actual audiences. Other stakeholders, such as corporate sponsors and artists also are involved in the problem situations.

By systematically examining these and other cases, patterns of stakeholder management can be identified. Illuminated by a variety of organizational theories, the patterns reflect resource dependencies, institutional pressures, and technical and moral constraints. Consistent with popular assumptions about nonprofits, we see a world where mission guides actions, tempered by economic concerns. Institutional pressures to provide "quality" arts experiences sometimes make it impossible for leaders to preserve resource flows. The cases reveal that older and larger nonprofits often face different types of issues and problems with stakeholders than their younger and smaller siblings and correspondingly interact differently with stakeholders. For example, older organizations may face greater inertia and resistance to change by staff, making adaptive responses technically more difficult. Most of all, the examination of cases shows the variety of strategic options available to organizational leaders to help them deal with the diverse pressures they face.

The study described in this book advances the understanding of stakeholder management in several ways. It offers a framework for categorizing problems or "threats" (Jackson & Dutton, 1988) that organizations may experience in their interactions with stakeholders. The categories highlight critical dimensions of the problems that seem to influence leaders' interpretations of the problems and consequently their strategic responses to them. The study also offers a framework for understanding responses available to leaders. The responses reflect a range of actions directed at changing an organization and/or the organization's stakeholders. The study also explores leaders' satisfaction with their responses and their

perceptions of stakeholders' satisfaction, which allows some prescriptive conclusions to be drawn.

The study tests predictions of responses using data primarily drawn from interviews with executive directors of nonprofit arts organizations. Minutes of board meetings, annual reports, grant proposals and other documents are used to elaborate the data provided by the directors. The interviews with directors, sometimes supplemented by interviews with board members and administrative staff, cover a total of eighty-three problem situations used for statistical testing of hypotheses. Appendix A provides a detailed description of the study methodology.

The frameworks of problem types, responses, and potential predictors of responses developed for the study are applied to nonprofit arts organizations, but the theories that inform the frameworks are generalizable to all organizations. The conclusions drawn from empirical testing of the model are lodged in the special context of the nonprofit arts sector. As some have argued (for example, Klausen, 1995; Gronbjerg, 1993), nonprofit organizations operate with unique organizational and environmental characteristics that make generic descriptions and prescriptions regarding management practices less valuable than ones that specifically incorporate a sector perspective and, even better, address a particular service or mission domain. Stakeholder-management practices in the nonprofit sector may differ from practices in the public or for-profit sectors. Further, the diversity of nonprofit organizations in the composition and character of their stakeholder relationships makes it difficult to offer conclusions that apply to all nonprofit organizations. We know that arts organizations operate with different revenue streams, regulations, competitors, and clients than social service organizations and other types of nonprofits (Salamon, 1992; O'Neill, 1989). Appendix A provides data on some of these characteristics for the organizations in the study.

This chapter proceeds by first laying a groundwork for the importance to organizations of congruence with stakeholders. Building from the idea of congruence, the chapter presents four types of problems with stakeholders that organizations face. Next, the chapter describes responses to the problem types. The chapter ends with a discussion of how the response strategies are related to other treatments of stakeholder management in the general organizational and nonprofit management literatures.

Organization and Stakeholder Congruence

Support to organizations from stakeholders is greatest when stakeholders interpret their interests, values, and norms to be congruent with an organization's purposes, activities, and outcomes. Stakeholders' interests and values determine to what extent they will see an organization's purposes, activities, and outcomes as desirable. As economic actors, if stakeholders believe that they can gain something of value from an organization, they are likely

to provide resources to the organization. Stakeholders' norms determine what organizational purposes, activities, and outcomes the stakeholders will see as appropriate or proper in a given set of circumstances. As moral actors, if stakeholders believe an organization is acting illegitimately, they are unlikely to support the organization.

According to resource dependence theorists, managers attempt to manipulate their environments to make them more stable and munificent, and they adjust their organizations to improve their ability to meet environmental demands (Pfeffer & Salancik, 1978). Managers' understanding of the congruence between the interests of their organizations and the interests of stakeholders guides their actions. Managers act in anticipation of positive feedback, such as acquisition of resources, and negative feedback, such as demands for accountability from stakeholders (Morgan 1983; Chandler, 1962). Although managers' interpretations of situations may be inaccurate and anticipated feedback unrealized, the interpretations and anticipations regarding feedback still influence interactions with stakeholders (Freeman, 1984). When interests are perceived by managers and stakeholders to be congruent, an organization and stakeholder are more likely to exchange resources (Pfeffer & Salancik, 1978).

Conferral of legitimacy on an organization by stakeholders is dependent on whether the stakeholders interpret the organization's purposes, activities, and outcomes to be congruent with their values and norms (Hannan & Freeman, 1984; Dowling & Pfeffer, 1975; Parsons, 1960). Managers may actively improve the congruence of their organization with stakeholders to encourage conferrals of legitimacy on their organization (DiMaggio, 1988). An organization's activities or outcomes may be found to be legitimate by some stakeholders and illegitimate by others because of conflicting values or norms held by the stakeholders. The ambiguity of reality also may result in different perceptions of legitimacy. The nature of organizational actions is rarely clear, and organizational leaders may act in ways that influence stakeholders to interpret organizational activities and outcomes differently (Pfeffer, 1981).

Organizational legitimacy is assumed to have many benefits. Being perceived by stakeholders as legitimate helps an organization to attract resources (Parsons, 1960), prevent opposition (Mueller, 1973), reduce demands for accountability (Simon, 1965), increase latitude for nonconformity (Starbuck, 1982), keep commitment of members (Kanter, 1972), and advance managers' personal interests in their career development and social acceptance (Sutton & Callahan, 1987). To gain or maintain support for their organizations, organizational leaders act to improve or maintain their legitimacy with stakeholders by influencing stakeholders' perceptions of the congruence of organizational purposes, activities, and outcomes with stakeholders' values and norms.

An organization obtains resources and other benefits from a stakeholder based on the stakeholder's interpretation of the organization's purposes, activities, and outcomes. Similarly, a stakeholder obtains resources and benefits from an organization based on organizational leaders' interpretations of the fit of the stakeholder's purposes, activities, and outcomes

with organizational interests, values, and norms. Leaders care about the legitimacy of the stakeholders with whom their organization interacts as well as their own organization's legitimacy. Leaders are unlikely to support stakeholders who are viewed as acting illegitimately. Also leaders are more likely to provide resources to a stakeholder whose interests are congruent with their organizations than to provide resources if interests are incongruent. Interpretations of congruence guide both stakeholders' and organizations' actions.

Stakeholder legitimacy is important to organizations because a stakeholder's low legitimacy may harm the organization's legitimacy. When some stakeholders who are closely tied to an organization act in ways that are inconsistent with other stakeholders' values and norms, the other stakeholders may regard the organization as lacking legitimacy. This is one reason that some organizations refuse to accept contributions or other types of assistance from stakeholders with "tainted" backgrounds. Some nonprofit organizations have specific policies stating that they will not accept donations from a corporation whose purpose appears to be inconsistent with their organization's mission. For example, organizations serving children or individuals with substance abuse problems may decide not to accept gifts from alcohol or tobacco companies.

Organizations are expected to have control over the activities and outcomes of individuals who work for them. Organizations also are expected to use their resources responsibly. For a for-profit firm this may mean using resources in ways that maximize profits within legal constraints. For a nonprofit organization this may mean using resources in ways that are morally and legally accountable and are consistent with donors' values and norms. Leaders who distribute resources to stakeholders who lack legitimacy may be failing to honor stewardship imperatives and may risk losing supporters' trust and confidence in their own organization's legitimacy. For example, if an artist performing under the auspices of an arts organization violates audience members' or donors' values and norms, it is not just the artist who may suffer a loss of legitimacy. The case of the National Endowment for the Arts shows how an organization can lose legitimacy with stakeholders simply by funding organizations that support artists whose work does not conform with conservative views about art (Frohnmayer, 1993). Similarly, if a board or staff member embezzles organizational funds or otherwise uses an organization improperly, the organization may be blamed. For example, local affiliates of the United Way lost legitimacy with donors because of the inappropriate actions of William Aramony, the former president of the United Way of America (Hall, 1995).

Even if they do not fear for their own organization's legitimacy, organizational leaders may see a relationship with a stakeholder who lacks legitimacy as problematic. Just as stakeholders allow their values and norms to influence who receives their resources, commitment, demands for accountability, and opposition, so do organizational leaders. All else the same, given choices of which stakeholders to satisfy, organizational leaders will choose those whose purposes, activities, and outcomes appear legitimate over those lacking legitimacy.

Types of Problems with Stakeholders Experienced by Organizations

Figure 1.1 presents four types of problems that an organization might experience with a stakeholder. All four types of problems involve a lack of congruence between an organization and stakeholder. In Cell I the problem involves a misfit between an organization's and a stakeholder's purposes, activities, or outcomes. Legitimacy is not an issue. Neither the organization nor stakeholder is perceived by the other to be acting inappropriately. The problem is that their interests are in conflict, not that values or norms have been violated. In Cell II, an organization's purposes, activities, or outcomes are incongruent with a stakeholder's values or norms. This results in the organization lacking legitimacy with the stakeholder. In Cell III, the reverse condition exists. A stakeholder's purposes, activities, or outcomes are incongruent with an organization's values or norms resulting in a stakeholder legitimacy problem. Organizational leaders believe the stakeholder's purposes, activities, or outcomes are inappropriate. Cell IV problems are latent. A stakeholder and organization have conflicting values and norms, but neither the stakeholder nor organization has acted in a way that has led to the other's disapproval of their purposes, activities, or outcomes.

Interest Clashes

Problems involving lack of congruence of a stakeholder's and an organization's purposes, activities, or outcomes belong in Cell I of Figure 1.1. Here, an organization and stakeholder's activities or outcomes are incompatible and interdependent. I label problems of this type "interest clashes" because in these situations, stakeholders or organizational leaders believe their interests are being harmed by the other's activities or outcomes. There is no violation of values or norms in this type of problem. The problems are economic or efficiency related, not moral in nature.

A variety of examples of interest clashes were discussed by executive directors interviewed for my study. For example, directors complained that stakeholders competed with their organizations for limited funds and audiences. In one case, a symphony director was frustrated by the actions of the artistic director of the university orchestra that was based in the same city. The artistic director's schedule of performances and rehearsals made it impossible for both orchestras to use student musicians and attract the same audience members. The competition did not violate values or norms but did constrain the community orchestra's fulfillment of its mission.

FIGURE 1.1
**Types of Problems with Stakeholders
Based on Lack of Congruence**

Stakeholder's	Organization's	
	Activities/Outcomes	Values/Norms
Activities/ Outcomes	I. Interest Clash	III. Stakeholder Legitimacy Problem
Values/ Norms	II. Organizational Legitimacy Problem	IV. Latent Conflict

Organizational Legitimacy Problems

Cell II of Figure 1.1 includes legitimacy problems resulting from an organization's violation of a stakeholder's values or norms. In my interviews, many directors discussed how their organization had acted wrongly according to stakeholders. For example, one director of a moveable arts space discussed a dilemma she faced when the leaders of one community told her that her organization should not be asking for donations at the door of the exhibit space. The community leaders explained that because the organization's visit was being sponsored by local businesses and government agencies, it was improper for the organization to ask community citizens for donations. The sponsorship monies did not completely cover the expenses of the visit, but the community leaders expected the organization to ask sources outside the community to make up the difference. The director responded to this legitimacy challenge by selectively stopping the donation requests and seeking outside funding to allow specially targeted groups in the community to visit the space without being solicited for contributions. She expressed her belief that, although it was standard practice for her organization to solicit donations at the door, the economic returns were not worth leaving community leaders with a bad feeling about the organization.

Stakeholder Legitimacy Problems

Cell III problems involve organizational leaders' interpretation of a stakeholder as lacking legitimacy. Here, a stakeholder's purposes, activities, or outcomes are not congruent with organizational values or norms. In the interviews, every director offered at least one story of a stakeholder who had acted illegitimately. In one case, a

wealthy and influential board member of a local arts council tried to charge the council for his efforts to arrange service contracts for the council. Adding to the conflict of interest offense, the services arranged by the board member were outside the council's mission. The board member had violated the values and norms of the organization by not working on its behalf, misrepresenting the organization's mission, and promising services without the approval of the full board as required by organizational policies. In response to the board member's actions, the other board members asked him to resign, cutting the organization's connection to a once-powerful stakeholder.

Latent Conflicts

Cell IV in Figure 1.1 represents problems involving lack of congruence of an organization's and stakeholder's values or norms. This type of problem is latent until one party violates the other's values or norms through its actions. When a violation of values or norms occurs, the result is a legitimacy problem belonging in either Cell II or Cell III.

Stakeholder-management patterns usually are more apparent in how fires are extinguished or dampened than in how fires are prevented. An element of perceived threat heightens leaders' attention to information about a situation (Jackson & Dutton, 1988.) When leaders acknowledge problems with stakeholders, they are likely to increase their awareness of actions relevant to the problem. Because leaders are more attentive to their "fire-fighting practices" than their prevention of fires, my study focuses on understanding the management of interest clashes and legitimacy problems and does not explore latent conflicts.

Benefits of Studying Congruence Problems

The four types of problems outlined above are ideals; complex situations may involve more than one of them. Multiple stakeholders may participate in a conflict situation, adding to the difficulty of problem sorting. Also, conflict situations may change and move among the cells over time. Still, use of this typology has several benefits for understanding the management of stakeholder relations.

First, use of the typology helps us understand whether differences in the values or norms of organizations and stakeholders affect organizational responses to stakeholders. It directly addresses the fact that organizations operate in environments with conflicting values and norms, instead of assuming that environmental pressures are consistent (Brunsson, 1989).

Second, the typology incorporates the construct of stakeholder legitimacy as well as organizational legitimacy. Most studies addressing legitimacy focus only on the influence and consequences of organizational legitimacy. These studies ignore the related proposition that organizational leaders' interpretations of stakeholder legitimacy influence organizational actions.

Third, understanding problems that involve legitimacy and contrasting them with problems that do not is of practical and theoretical importance. The institutional literature argues that concerns about organizational legitimacy motivate organizational actions (for example, Oliver, 1991; Meyer, Scott & Deal, 1981). I add that managers' interpretations of stakeholder legitimacy motivate organizational actions. Rational approaches emphasize efficiency and economic problems (interest clashes) as motivators of organizational actions (for example, Williamson, 1975; Weber, 1947). This book presents tests of the importance and effects of these different motivators in influencing organizational actions and, ultimately, organizational stakeholders.

Fourth, the typology operates whether stakeholders are internal or external to an organization. This is important because stakeholders exist inside and outside organizations and organizational managers respond to both internal and external interests. Nelson (1989) argues that empirical studies have tended to look only at conflicts within organizations, that is, at conflicts among internal stakeholders. Rarely have scholars simultaneously examined conflicts with internal and external stakeholders. Most of the scholars who have done so have used single case studies (for example, Stapleton, 1995, with the University Circle Development Foundation; and Zald and Denton, 1963, with the Young Men's Christian Association). This study extends the literature by conceptualizing and empirically examining responses to problems involving internal and external stakeholders in multiple organizations.

Responses to Problems with Stakeholders

There are two general approaches that organizational leaders might use when addressing problems with stakeholders: (1) improve congruence interpretations and thus resolve or diminish the problem, and (2) attempt to reduce the negative consequences of the problem. The approaches include a variety of strategies, as shown in Table 1.1.

Other approaches and responses to the problems exist that are not shown in the table. For example, leaders may choose to ignore a problem and not actively respond. Leaders also may use an identification strategy to combat organizational legitimacy problems. When leaders link their organization to a symbol, event, or institution that a stakeholder regards as highly legitimate, the stakeholder may interpret the organization as sufficiently legitimate to merit resources and other benefits, even if some of the organization's purposes, activities, or outcomes appear inappropriate (Kamens, 1977; Meyer & Rowan, 1977). The framework of responses presented in Table 1.1 and discussed below covers the active and conscious responses to problems with stakeholders, minus the identification strategy. The identification strategy is not explored in depth in this study because of the difficulty in measuring it using retrospective reports and its relevance only to organizational legitimacy problems.

TABLE 1.1

Responses to Problems with Stakeholders

PROBLEM TYPES			
	Organizational Legitimacy Problem	Interest Clash	Stakeholder Legitimacy Problem
APPROACHES			
Improve Congruence Interpretations	Adapt organization's activities or outcomes	Adapt organization's activities or outcomes	Adapt organization's values or norms
	Misrepresent organization's activities or outcomes	Misrepresent organization's activities or outcomes	Misrepresent organization's involvement with stakeholder lacking legitimacy
	Change stakeholder's understandings, values, or norms	Change stakeholder's activities or outcomes	Change stakeholder's activities or outcomes
	Compromise—adapt organization's activities or outcomes and change stakeholder's values or norms	Compromise—adapt organization's activities or outcomes and change stakeholder's activities or outcomes	Compromise—adapt organization's values or norms and change stakeholder's activities or outcomes
Influence Consequences of Incongruence	Change ties to stakeholder	Change ties to stakeholder	Change ties to stakeholder

Responses to Organizational Legitimacy Problems

There are several ways a manager can improve a stakeholder's interpretation of congruence, and thus the stakeholder's conferral of organizational legitimacy. One way is to adapt the organization to better match the stakeholder's values and norms. By changing the organization's purposes, activities, or outcomes, the stakeholder may see the organization as more legitimate. One arts center adopted this approach when it responded to a ticket buyer's complaint that the organization was deceptive in describing seating arrangements for dinner shows. The ticket buyer accused the organization of giving patrons worse seats than had been promised. The center did not want any hint of scandal; it reorganized the seating to better reflect the seating chart shown to ticket buyers. The organization adapted to meet the ticket buyer's values and norms concerning honesty in advertising.

Another way to improve interpretations of congruence is to change a stakeholder's understanding of an organization's purposes, activities, or outcomes by offering a more desirable view of them, in other words, a "positive spin" (Sutton & Kramer, 1990). Some theorists claim that the most important job of organizational leaders is to interpret organizational

events for stakeholders (Pfeffer, 1981). Leaders' descriptions of actions influence stakeholders' interpretations of the actions, as do explanations of why the actions occurred and predictions about their future occurrence. Leaders can change stakeholders' understanding of events by introducing new concepts and values and suggesting cause-effect relationships (Gray , Bougon & Donnellon, 1985). Specific interpretation techniques, such as accounts, excuses, and apologies, can be used to prevent or repair damage to organizational legitimacy (Benoit, 1995; Scott & Lyman, 1968). Organizational leaders may be able to persuade stakeholders to accept a meaning for organizational actions that fits the stakeholders' values and norms. Also, stakeholders' interpretations might be negative because they are missing critical information or have incorrect information. By offering new information, organizational leaders may improve stakeholders' conferrals of legitimacy on their organizations.

For example, one director faced a group of angry volunteers who felt the organization unfairly refused to allow them to implement a fundraising project. The volunteers felt the organization should not be turning down money-making opportunities, and that the refusal was based on board members' dislike of the volunteers. Once the director explained why their project was likely to lose rather than make money, and how the project would divert needed resources from direct service activities, the volunteers agreed that the refusal was appropriate.

Sometimes the information offered by organizational leaders misrepresents or conceals their organizations' actual purposes, activities, and outcomes. When stakeholders' norms are inconsistent, the organizations' leaders may reflect the inconsistencies by presenting their organization differently to the stakeholders. By presenting one view to one stakeholder and a different view to another stakeholder, the leaders may be able to preserve adequate levels of legitimacy with both, particularly if the stakeholders are not in direct contact and are unlikely to learn of the differences (Brunsson, 1989). Organizational leaders also may choose to deceive stakeholders if providing accurate information would be harmful to their organization. For example, leaders of an arts council that ended its affiliation with another organization publicly represented the split as amicable. In actuality, there was much ill will between the two agencies and anger over the disposition of funds donated to one organization but kept by the other. The director explained that concealing the true situation was justified. She stated:

> It has worked out in the long run to have done it that way because we're here to serve those eighteen communities, and I think the mayors respect how it was dealt with. Also, if we'd left making a real stink—let's say I think people don't always read the fine print; they just see negativity. They skim the article and what's left in their mind is [that] bad things are happening with the arts council. Businesses do not fund controversial organizations.

To convince stakeholders of their organization's legitimacy, an organizational leader may try to influence the values and norms that stakeholders are using to evaluate the organization's purposes, activities, and outcomes (Brunsson, 1989). There is rarely one clear measure on which an organization may be judged, which gives organizational leaders some flexibility in justifying their organization. By changing which values and norms a stakeholder applies to a situation, a leader may improve organizational legitimacy.

This strategy was used by an arts council that was accused of discriminating against small agencies in its grantmaking practices. Representatives from the smaller arts agencies felt that grants from the arts council should be equally distributed across all the arts agencies in the community. The director responded by trying to change the small arts agencies' values regarding the best criteria for grantmaking. Representatives from the small agencies were invited to meetings in which the council attempted to justify its funding allocation scheme. Council leaders explained that there was greater overall benefit to the community with use of prior effectiveness and program merit as funding criteria, rather than with use of an equal-distribution or size criterion. In the meetings, small agencies were told to promote their agencies' effectiveness and merit in their grant proposals, instead of treating council grants as entitlements. The director of the arts council hoped that the representatives from the smaller agencies left the meetings believing that the arts council was acting appropriately in its grantmaking activities.

Another approach to managing an organizational legitimacy problem is for a leader to compromise with a stakeholder to improve congruence interpretations. With compromise, an organization and stakeholder negotiate an acceptable solution to an incongruence problem. The solution involves change to both the stakeholder and organization.

The experience of a community theater helps illustrate the use of a compromising strategy. The theater was experiencing conflicting pressures from theater members: some members were pleased by the increasing level of professionalization in the casting of shows; other members wanted the theater to retain its mission as a community theater and provide more opportunities for less skilled community members to perform. The two groups fought over the proper role for the theater to play. The organization reduced the conflict by explicitly changing its programming and casting to incorporate the dual missions. Some shows were chosen and cast with quality as the decision criterion. The primary purpose of other shows was to allow actors at a variety of skill levels to be involved in the production. Both membership groups agreed to accept the dual-mission orientation. The compromise satisfied both stakeholder groups.

The second general approach for managing an organizational legitimacy problem is to influence the potential consequences of the problem instead of directly addressing the problem. To change potential consequences, organizational leaders may change their organization's connection to a stakeholder. This may help leaders control the degree and type of influence a stakeholder has on their organization. More or less interdependence between an organization and stakeholder can be created.

Greater interdependence can be created with an external stakeholder by cooptation, or giving the stakeholder an internal role in the organization with accompanying decision-making power (Pfeffer & Salancik, 1978). Cooptation neutralizes a stakeholder's opposition and enhances the stakeholder's perceptions of organizational legitimacy (Oliver, 1991). Cooptation is effective because with increased interaction, the stakeholder becomes socialized to the values and norms of the organization and becomes visibly linked with the organization. A stakeholder who feels responsible for an organization's activities and outcomes is less likely to interpret the organization as lacking legitimacy and to create difficulties for the organization (Pfeffer & Salancik, 1978).

A director of a museum reported how her organization once was engaged in a battle over who should be allowed to control a pot of donated money earmarked for a particular use. The museum had legal rights to the bequest. Another agency in the community existed to advance the purpose earmarked by the money and demanded control over it, arguing that the museum did not have the expertise to adequately honor the donors' wishes. The museum responded by placing a representative of the agency on the museum's board to "make suggestions and monitor the disposition of the funds." The agency fighting for control of the money was effectively coopted and the museum gained the agency's expertise and support.

Cutting or weakening a stakeholder's ties to an organization creates less interdependence of the stakeholder and organization and may decrease negative consequences of an organizational legitimacy problem. Limiting interaction with a stakeholder may protect important elements of an organization from a stakeholder's interference. Core activities of an organization may be buffered or decoupled to reduce stakeholders' scrutiny or control (Meyer & Rowan, 1977). Also, stakeholders' authority or responsibilities within an organization may be reduced. Besides weakening stakeholders' ties to an organization by creating barriers for evaluation and control, stakeholders whose values or norms lack congruence with an organization's purposes, activities, or outcomes may be encouraged or required to leave the organization. For example, organizational leaders may fire staff members and discourage board members from sitting on important committees.

A director of a symphony orchestra gave me a good illustration of the strategy of diminishing influence. The symphony had been criticized by some of its musicians for changing its focus to emphasize quality over community participation. The symphony gradually replaced musicians to increase the symphony's quality, often drawing replacements from outside the area. The board and executive director ignored complaints about the symphony's loss of community participation. As the replacements took place, the complaints gradually quieted as the musicians fighting against the loss of community participation grew smaller in number and less powerful among their peers.

In sum, organizational leaders may approach an organizational legitimacy problem by influencing stakeholders' interpretations of congruence, and reducing negative consequences of the congruence interpretation. With the first approach, leaders may adapt or misrepre-

sent their organization's purposes, activities, or outcomes; attempt to change a stakeholder's values or norms; or compromise with a stakeholder. With the second approach, leaders may change organizational ties to the stakeholder to increase or reduce interdependence of the organization and stakeholder.

Responses to Stakeholder Legitimacy Problems

Organizational leaders also have a variety of options in responding to stakeholder legitimacy problems. Leaders may improve congruence interpretations by adapting their organization's values or norms; trying to change a stakeholder's purposes, activities, or outcomes; or compromising. To reduce negative consequences of low stakeholder legitimacy, leaders may change ties to a stakeholder. Leaders also may use misrepresentation or concealment in response to stakeholder legitimacy problems.

The adapting response for stakeholder legitimacy problems involves an organization's changing values or norms to be more congruent with a stakeholder's existing purposes, activities, and outcomes. For example, some arts organizations in my study adjusted their values to be more consistent with the activities of the public they were trying to reach. One symphony board redefined the value of "movie music" and began promoting it as an important art form, justifying the organization's initiatives to reach audience members who would not attend anything except pop music concerts. In the past, the symphony's artistic director and board members had rejected the programming preferences of this audience, believing that their pop-oriented tastes were less legitimate than those of the symphony's traditional audience, which loved classical music by long-dead composers.

Another option for responding to stakeholder legitimacy problems is to use persuasion or coercion to convince stakeholders to change their purposes, activities, or outcomes. For example, the board of an arts council coerced volunteers who were inappropriately using council funds on elaborate parties. The parties were supposed to celebrate openings of events and attract patrons. Instead, they were serving as entertainment for volunteers. The board imposed strict budgeting requirements, and informed the executive director that party details had to be submitted to the administrative staff for approval before any funds were released to volunteers.

Compromising is another option for responding to stakeholder legitimacy problems. An arts council faced the problem of how to deal with a school system that was not honoring formal contracts booked through another agency. Both the school system and booking agency appeared to be reneging on promised work and payments. The conflict was resolved by having all three parties renegotiate the contracts. Although the council did not receive all the financial benefits originally promised and did not regain trust in the booking agency, the council leaders agreed that under the circumstances the best possible solution had been reached.

Changing ties to a stakeholder may be useful to organizational leaders when a stakeholder lacks legitimacy. By increasing or reducing interaction with a stakeholder, an organization may be able to reduce negative consequences to the organization of the stakeholder's inappropriate purposes, activities, or outcomes. Establishing systems for increased interaction, and thus the opportunity for greater monitoring and supervision, can indicate to stakeholders that the organization is in control of a problematic situation and will not allow future improprieties to occur. Showcasing new control systems may help organizational leaders regain trust that was lost from some stakeholders when it "permitted" other stakeholders to improperly use organizational resources. For example, the council that required volunteers to submit budgets and get approval for parties can now show donors that the organization has more control over the use of funds.

By decreasing interaction, an organization can indicate to other stakeholders that it does not approve of a stakeholder's purposes, activities, or outcomes. For example, the board of an arts center publicly reprimanded the director of a theatrical production who dropped her slacks after a performance, allegedly following a New York custom. The actors who experienced the action were offended and complained to the board. The director of the production, who was also a board member, resigned from the board after the reprimand. It was clear to all involved that she probably would not direct another play for the organization. Her violation of local norms and the resulting reprimand led, as the board expected, to her loss as a volunteer.

Leaders may use misrepresentation in response to a stakeholder legitimacy problem, but in a different way than it might be used for other types of problems. Misrepresenting their organization to a stakeholder lacking legitimacy would not improve organizational leaders' approval of the stakeholder. The misrepresenting response is more likely to be targeted at other stakeholders not directly involved in a stakeholder legitimacy problem. By not letting other stakeholders know that the organization is involved with a stakeholder lacking legitimacy, the organization's legitimacy with these other stakeholders may be preserved.

In sum, organizational leaders have several options for responding to stakeholder legitimacy problems. Use of adaptation and compromise involves some change to an organization's values and norms. Compromise and trying to change a stakeholder's purposes, activities, or outcomes focus on influencing a stakeholder to adapt to an organization's existing values and norms. Changing ties to a stakeholder manipulates the level and type of interaction an organization experiences with a stakeholder to reduce negative consequences of a stakeholder legitimacy problem to the organization. Misrepresenting may be used to prevent a stakeholder's lack of legitimacy from influencing perceptions of an organization's legitimacy.

Responses to Interest Clashes

Many of the options available for responding to legitimacy problems also may be used to manage interest clashes. Organizational leaders may improve congruence of interests by adapting their organization, compromising, misrepresenting their organization, or trying to change a stakeholder. Organizational leaders also may influence the negative consequences of an interest clash by changing ties to a stakeholder.

Much of the management literature concentrates on how to adapt organizations to reduce interest clashes with stakeholders. For example, marketing and strategy texts discuss how organizations can change directions to fill market niches and reduce competition. Human resource management theories explain how managers can improve evaluation and reward systems to motivate employees to act in ways that advance both organizational and employees' interests. In my interviews, directors discussed several types of organizational changes instituted to reduce conflicting interests. As examples, one director talked about changing purchasing practices to meet a supplier's interest in more predictable sales. Another director discussed how programming initiatives were adjusted to meet foundation funding interests.

Compromise may be used to make an organization's and stakeholders' interests more compatible. Conflict resolution strategies generally take an interest-based negotiation approach, focusing on identifying shared interests and developing solutions to complement the shared interests while diminishing the importance of conflicting interests (for example, Fisher and Ury, 1981). One director explained how she asked various groups using her facilities to negotiate agreements to reduce the problems created by limited parking and interference in one another's program activities. The organization agreed to change its parking policies and increase available parking spaces and the groups agreed to spread their use of the facility more evenly over the week. Several arts center directors discussed how they worked closely with other arts organizations in their communities to coordinate schedules. By not scheduling overlapping events and by compromising on which organizations would use the most attractive dates, the organizations reduced their competition for audience members, helping all the organizations involved.

To improve coordination of interests, organizational leaders can try to change a stakeholder's purposes, activities, or outcomes without changing their organization. Leaders may solicit the support of stakeholders, promoting the shared interests of the organization and stakeholders. Leaders also may tell a stakeholder that their activities or outcomes are harming the organization, hoping that the stakeholder will change. For example, one director explained how she told local media representatives that their coverage of other arts organizations and lack of coverage of her organization made it difficult for her organization to raise funds in the area. The media representatives did not intend to put her organization at a disadvantage, but were driven by information and space constraints. Once the media representatives were

informed of the problem, they adjusted their practices to include the organization in their news reports.

Organizations also may try to coerce a stakeholder into changing. For example, one arts council had difficulty completing its annual reports because grant recipients were late in turning in final reports of their activities. The grant recipients felt that their time was better spent on activities other than the reports. The council eventually informed recipients that if they did not turn in their reports on time, they would be ineligible for future funding. The threat worked and reports came in on time.

Another way to respond to interest clashes is to misrepresent or conceal an organization's activities or outcomes to a stakeholder. By not letting a stakeholder know what an organization actually is planning or doing, a manager may be able to avoid undesired interference in organizational tasks. For example, an arts organization may keep its donor lists secret to prevent other organizations from soliciting the organization's supporters. Until success seems certain, organizations also may misrepresent their program innovations and goals to prevent other organizations from capitalizing on any failures or preempting any opportunities.

An organization's leaders may change their organization's interdependence with a stakeholder in response to interest clashes. By increasing interdependence, an organization may gain additional knowledge and control of a stakeholder's activities and outcomes. Although the discretion of organizational leaders is diminished by greater interdependence, exchanges with a stakeholder are more certain and predictable (Pfeffer & Salancik, 1978). For example, a director interviewed for the study mentioned that both artists and corporate executives were given seats on the board with the expectation that they would represent conflicting interests. The board setting provided a forum for expressing and balancing the conflicting orientations. The board's decisions consequently were more moderate and successful in addressing both artistic and business interests.

Another option for organizational leaders is to reduce interdependence with a stakeholder. For example, leaders of one arts organization in the study ended their organization's involvement with an umbrella organization when they determined that their organization would have more autonomy and public support without an association with the other organization. The organization incorporated as an independent entity and no longer was forced to share its resources with the other organization.

In sum, organizational leaders may approach interest clashes with the same types of approaches and responses used for legitimacy problems. They may improve congruence or interpretations of it, or reduce the negative consequences of incongruence. For interest clashes, attempting to change activities or outcomes to improve congruence is more relevant than changing values and norms.

Other Organizational Literature Offering Stakeholder-Management Frameworks

The responses to problems outlined above are consistent with the few other treatments of stakeholder-management strategies, and reflect advances in our understanding of organizational actions in response to stakeholder pressures. One of the earliest formulations of stakeholder-management strategy is offered by Dowling and Pfeffer (1975). Dowling and Pfeffer discuss three approaches for gaining and ensuring society's conferral of legitimacy on an organization. First, an organization can adapt to conform to society's definitions of legitimacy. This matches my response of adapting an organization's activities, outcomes, values and norms to conform to a stakeholder's values and norms. Second, an organization can attempt to alter the definition of legitimacy to conform to the organization's current activities, outcomes, and values. This matches my response of manipulating values or norms. Third, an organization can use identification as a means for gaining and ensuring legitimacy. An organization can influence stakeholders' conferrals of legitimacy by associating itself with highly legitimated institutions, symbols, or practices. With an identification strategy, an organization's actual purposes, activities, and outcomes may have less influence on stakeholders' conferrals of legitimacy than the symbols presented to indicate legitimacy.

Dowling and Pfeffer discuss their three strategies of adapting the organization, manipulating society, and using identification as ways to improve *society's* conferral of legitimacy. Pfeffer and Salancik (1978) subsequently modify Dowling and Pfeffer's framework to say the strategies are useful in influencing legitimacy conferrals by *individuals* or *coalitions* of stakeholders. Pfeffer and Salancik argue that what is important to organizations is having legitimacy with a sufficient number of key stakeholders, not with society as a whole. This view is consistent with the argument set forth in this book. Organizational leaders operate in environments with multiple and often conflicting values and norms. No one set of values and norms is shared by all members of a society or even an institutional domain. Organizational leaders may choose which stakeholders to satisfy and which to leave unsatisfied. It is often difficult, if not impossible for organizations to completely satisfy all their stakeholders.

Ashforth and Gibbs (1990) add to the understanding of stakeholder management by differentiating between substantive and symbolic methods for gaining, defending, and maintaining organizational legitimacy. Substantive management is the "real, material change in organizational goals, structures, and processes or socially institutionalized practices." Symbolic management involves changing the way organizations appear to stakeholders. It addresses the transformation of the meaning of acts, not the acts themselves.

Ashforth and Gibbs' substantive management category includes four types of practices. The first type, role performance, involves an organization's meeting a stakeholder's performance expectations. The second practice, coercive isomorphism, is defined as an organization's conformity to the values, norms, and expectations of stakeholders. The third practice, altering resource dependencies, involves increasing freedom for an organization by changing the

mix of dependency relationships with stakeholders. The fourth practice, altering socially institutionalized practices, is defined as bringing institutionalized practices into conformity with an organization's activities and outcomes. These substantive management practices can be matched to my responses. Role performance and coercive isomorphism correspond to adaptation of an organization. Altering resource dependencies corresponds to changing ties to stakeholders. Altering socially institutionalized practices is consistent with attempting to change stakeholders' purposes, activities, and outcomes when "stakeholders' practices" are substituted for "socially institutionalized practices."

Ashforth and Gibbs include six practices under symbolic management. The first practice is espousing socially acceptable goals while pursuing less acceptable ones. The second is denial and concealment of activities and outcomes. The third practice is redefining or reframing means and ends to influence stakeholders' interpretations of them. The fourth practice is offering accounts, defined as explaining a situation in a way that excuses or justifies an organization's activities or outcomes. The fifth practice is offering apologies or acknowledging at least partial responsibility for a negative event. The sixth practice is ceremonial conformity or adopting highly visible practices for stakeholders while keeping core technologies intact. My response of changing stakeholders' values or norms may involve symbolically redefining means and ends. Misrepresentation and concealment in my framework incorporates some of Ashforth and Gibbs' symbolic management practices, particularly denial, concealment, and espousing socially acceptable goals while pursuing less acceptable ones.

In practice, it is difficult to differentiate responses according to their substantive or symbolic nature. Organizational leaders couple substantive actions with symbolic actions (Pfeffer, 1981). Actual adaptations, changing of ties, and compromises by managers may be accompanied by symbolic presentations of these actions to stakeholders. Also, responses may occur sequentially. A single "snapshot" of a response to a situation may capture only part of the stream of symbolic and substantive actions.

For example, an arts council might describe new grantmaking procedures in a variety of ways. The changes could be described as the result of severe funding cuts, pressures to show accountability, desire to empower grant recipients, etc. The actual grantmaking procedures do not differ with the alternative meanings, but the stakeholder's understanding, acceptance, and response to the procedures could change, depending on the description. The substantive action (the new procedures) are combined with the symbolic action (the explanations and justifications for the changes) to influence the council's relationship with its stakeholders. Over time, new issues related to the grantmaking procedures may arise, inspiring new organizational responses.

My study acknowledges and partially addresses the distinction between substance and symbol by examining the values and norms that influence understandings of purposes, activities, and outcomes. Purposes, activities, and outcomes are substantive outputs, while

values and norms inform the meanings of these outputs. When organizational leaders trigger stakeholders' values and norms, they are shaping the stakeholders' expectations and constraining meanings. Because my data on responses is from retrospective reports rather than observations, much of the symbolic activity surrounding the responses may be lost. The actual words and other symbols used to introduce responses to stakeholders could not always be reconstructed in the interviews and thus are unavailable for analysis.

The responses examined in my study are argued to be conscious, active, and self-interested responses by organizations to problems or threats associated with the organizations' interaction with specific stakeholders. Organizations also respond to pressures in their environments that are not tied to particular stakeholders. Responses may be performed without any active agency or awareness. That is, they may occur because of habit or conformity to taken-for-granted rules or values. Oliver (1991) provides a comprehensive review of passive to active responses to institutional pressures. The responses outlined in this study are a subset of the responses that organizations may make in response to their environments.

Leaders manage relationships and situations with stakeholders that they perceive to be non-problematic as well as problematic. While organizational leaders are responding to problems or to threatening issues associated with some stakeholders, they also are managing relationships with other stakeholders with whom their organization is congruent in purposes, activities, outcomes, values, and norms. Savage, Nix, Whitehead and Blair (1991) distinguish stakeholders according to their potential to cooperate with or to threaten an organization. Their strategy framework is largely prescriptive, differentiating strategies for supportive stakeholders from nonsupportive ones.

Very little is known about what strategies are actually used by leaders to respond to issues and problems associated with stakeholder relationships. Oliver systematically develops predictors of responses to institutional pressures, but her predictions have not yet been directly tested and are not explicitly linked to stakeholder management. Savage et al. offer management prescriptions but fail to empirically support their usefulness and provide minimal theoretical justification. This study predicts and explores the patterns displayed in the use of strategies for improving congruence interpretations and influencing consequences of incongruence. It builds from existing work by organizational theorists to provide a model of the management of problems with stakeholders.

Literature Related to Stakeholder Management by Nonprofit Organization Scholars

A multitude of books and articles explore the special features of nonprofit organizations and the resulting management challenges. Some of these works offer insights helpful for understanding the management of stakeholder relationships in the nonprofit sector. Typical

features of nonprofit organizations are their missions to serve multiple stakeholders with potentially conflicting needs and expectations (Hodgkin, 1993); diversity of revenue streams, which adds to the complexity of stakeholder mixes (Oster, 1995; Gronbjerg, 1993); nature as institutions embodying public trust and service, which heightens moral accountability (Hodgkin, 1993); relatively intangible outcomes, making financial profit tests inappropriate and requiring consideration of multiple stakeholder interests to evaluate effectiveness (Kanter & Summers, 1987); and more active and perhaps effective boards than those in the for-profit sector (Drucker, 1990), which makes their leadership more often dependent on a coalition of actors than on a single administrator. Some types of nonprofits fit this conception better than others. For example, mutual benefit nonprofits, such as country clubs, may serve less of a public service function and therefore be governed with less of a moral imperative than other types of nonprofits, such as art museums or environmental advocacy organizations.

Nonprofit management scholars acknowledge the permeable nature of nonprofit organizations and the diversity of their stakeholders, but few offer theoretical frameworks or empirical investigations of stakeholder management. The lack of attention to stakeholder management in the nonprofit sector is surprising, given the popular assumption that resource scarcities are forcing nonprofits to increasingly function as open systems. In their review of research on nonprofit strategy, Stone and Crittenden (1993) suggest that more work is needed on how organizations cope with multiple stakeholders. Heimovics, Herman, and Jurkiewicz (1995) argue that effective nonprofit executives engage in political activities (including dealing with conflicts among stakeholders and bargaining) more than less effective executives. In their study, political activities were the only types of activities that significantly distinguished the effective nonprofit executives from the less effective ones. This finding reinforces the practical need to examine carefully what is involved in managing problems with stakeholders in nonprofit contexts.

Most research on nonprofit organizations that is not based on a single case focuses on organizational relationships with one type of stakeholder. For example, Smith and Lipsky (1993) explore nonprofit relationships with government contractors. Gronbjerg (1993) dissects the relationship of funders with nonprofit social service and community development organizations. These works offer a rich picture of patterned interactions with stakeholders. They confirm the view of organizations as "open systems" handling diverse resource streams. They also reinforce the need to look carefully at the institutional context of the service fields or mission areas of the nonprofit organizations being studied.

Of the few nonprofit organization scholars who look at multiple stakeholders, most focus on examining the stakeholders' perceived importance rather than strategies for managing relationships with stakeholders. Adams and Perlmutter (1995) examine the relative importance that boards and executives place on managing internal operations versus external relations. For their sample of family service agencies, it appears that both executives and board members place higher priority on working with internal stakeholders on planning, program de-

velopment, and defining mission, and place lower priority on direct outreach to external stakeholders, such as public agencies, other nonprofits, for-profits, and the local community. This finding is somewhat inconsistent with that of Heimovics and Herman (1990), who find that nonprofit executives describe their most critical events as those involving contact with external stakeholders.

The relationship between boards and executive directors receives considerable attention from nonprofit scholars. Board members and directors are traditionally thought to have different responsibilities and to carry out different functions in nonprofit organizations. However, Herman and Heimovics (1989) and Heimovics and Herman (1990) argue that both boards and directors engage in policy making and management, and that directors tend to be held more accountable than boards for organizational outcomes. This leads to a question of whether it is the board, director, or both who coordinate the management of organizational relationships with stakeholders.

My interviews revealed a variety of arrangements of board and executive director responsibilities. Some directors reported that their organizations followed the popular prescription of having the board set policy and the staff implement it. One director whose organization had this arrangement stated, "I have generally enjoyed a clear commitment by the board to limit itself to governing and leave management to the professionals." Other directors reported a more fluid division of responsibilities. One stated, "With the board right now I think that I am probably working on both sides of the fence, unofficially as a board member [and] executive director." Another director stated, "They [the board] get more involved in everyday operation than they should, but they have to because I don't have enough staff." At the far extreme, one director, who had never worked with a board that met his performance standards, reported bitterly that he sets the vision and policies for the organization, not the board. He stated, "So I've gotten away from saying that I want a policy board, saying I want a hard-working board. And I set the policy and they can deal with that."

These varying arrangements of board and director responsibilities are evident in stakeholder-management activities. In 67 percent of the cases in my study both the director and board were involved in managing a problem with a stakeholder. In 13 percent of the cases, staff members other than the executive director managed the problem. No problems in the sample were managed by the board alone, which may be because of the use of executive directors as the primary source of information. The directors may be more familiar with problems that they managed (or their staff managed) than with problems managed solely by board members. Another explanation is that boards rarely manage stakeholder problems without help from a director or staff. A review of board minutes supports this second explanation. Unless their stakeholder-management activities were off the record, board members seldom independently managed problems with stakeholders. Even when a problem was presented by a board member, the executive directors usually helped decide how the organization would respond, although board members often implemented the response.

In this book I have been using the term "organizational leaders" to describe the guardians and promoters of an organization's interests, integrity, reputation, and image. Ideally, a non-profit organization's leadership would include its board members and executive director. However, board members and directors may act in their own interests or according to their personal values and norms rather than in the organization's interests or according to organizational values and norms. In these cases, a board member or director is considered a stakeholder rather than an organizational leader.

Table 1.2 displays the types of stakeholders involved in the problems discussed by directors for the study. In general, the directors reported as many problematic relationships with internal stakeholders (artistic and administrative staff and volunteers, and board members) as external stakeholders (other arts organizations, patrons, contributors, media, business contacts, and noncontractual artists). No cases involved an executive director acting as a stakeholder.

TABLE 1.2
Sources of Problems and Their Frequency

Type of Stakeholder	# of Cases in Study	% of Cases
External Stakeholder:		
Arts Organizations	12	14%
Patrons	8	10%
Contributors	7	8%
Media	3	4%
Artists	3	4%
Business Contacts	3	4%
Other	5	6%
Total External Stakeholders	41	50%
Internal Stakeholders:		
Board Members	11	13%
Artistic Staff	11	13%
Artistic Volunteers	8	10%
Administrative Staff	6	7%
Administrative Volunteers	6	7%
Total Internal Stakeholders	42	50%

Note: Some theorists consider board members to be external rather than internal stakeholders (for example, Mintzberg, 1983). This is an appropriate designation when a board member is an appointed representative of external interest groups and is not involved in day-to-day decision making (the typical "outsider" corporate board member). However, in small- to medium-sized nonprofit organizations, board members often perform routine operational tasks. As Sukel (1978, p. 351) noted, board members of arts organizations "seem to become more involved in what, by business standards, might be considered 'picayune' matters." When board members work side by side with the staff and director, they are properly considered to be internal organizational members rather than external governance agents.

The nonprofit literature suggests that the source of organizational leadership may shift, depending on an organization's state of crisis. Miller, Kruger, and Glass (1994) found that boards are most active when they are reducing a serious threat and returning their organization to equilibrium. Under more positive conditions, boards play a less active role. The growth stage of a nonprofit also may make a difference in whether its board or executive director takes a leadership role in managing problems with particular stakeholders. Depending on the stage of an organization's life cycle, boards may be more or less involved in strategic and operational activities (Ostrowski, 1990). In my study, there was a strong negative correlation between age of the organization and the board's involvement in managing stakeholders' problems.

This review of the nonprofit literature raises four issues that prompt further attention. First, legitimacy problems may be acknowledged and addressed more vigilantly in nonprofit organizations than in their for-profit counterparts. Business executives may be more concerned with interest clashes that can influence their bottom line. Nonprofit leaders may place more weight on values and norms in guiding their actions (Hinings & Greenwood, 1988; DiMaggio, 1986; Van Til, 1994) Legitimacy problems may threaten a nonprofit organization's integrity, image, base of support, and member's commitment.

Second, the nonprofit literature suggests that a nonprofit organization's mission has a central part to play in understanding the organization's activities and outcomes, and stakeholders' assessments of those activities and outcomes. The mission also affects the types of internal and external stakeholders involved with an organization. Therefore, mission should not be ignored in studying stakeholder relationships.

Third, nonprofits typically have different kinds of resource needs than for-profit or government organizations. For example, nonprofit arts organizations may rely heavily on volunteer time, donations, and grants. Understanding the dependencies these needs impose is critical to understanding stakeholder-management practices.

Fourth, examining who is fulfilling the leadership role in managing stakeholders may be critical to the development of practical implications for stakeholder management. Also, if executive directors are blamed for organizational problems, even when they are not active in addressing the problems (Heimovics and Herman, 1990), then exploring the directors' substantive and symbolic (Pfeffer, 1981) roles in the stakeholder-management process adds a critical dimension to the story this book tells. Understanding the nature of problems with board members and the management of the problems also is critical. Stakeholder management becomes more complex when the activities of those chosen to govern also need to be governed.

Summary

This chapter presented frameworks used in building my study of stakeholder management in nonprofit arts organizations and linked them to organizational and nonprofit lit-

eratures. Four types of problems with stakeholders were discussed: interest clashes, organizational legitimacy problems, stakeholder legitimacy problems, and latent conflicts. All four problems are the result of lack of congruence of an organization and stakeholder. To respond to these problems, organizational leaders choose from a variety of strategies. If they wish to change interpretations of congruence, the leaders may adapt their organizations, try to change stakeholders, misrepresent or conceal information, or compromise. To reduce negative consequences of problems, organizational leaders may weaken or strengthen organizational ties to stakeholders. The next chapter explores potential predictors of these responses to problems with stakeholders.

2

PREDICTING RESPONSES TO
PROBLEMS WITH STAKEHOLDERS

The first chapter presented the responses available to organizational leaders to address stakeholders' problems. Our understanding of stakeholder management multiplies if we can discern patterns in the use of these responses. This chapter examines possible influences on use of responses. Characteristics of stakeholders, problems, and organizations are likely to influence the process leaders use to scan their environment for problems, interpret the problems and respond to them. Characteristics related to stakeholders include stakeholders' importance based on resource dependencies, stakeholders' decision-making authority in the organization, stakeholders' access to information on the organization, and stakeholders' interaction with organizational workers. Problem characteristics include the problem type (interest clash, organizational legitimacy, or stakeholder legitimacy problem), whether the problem threatens organizational mission or involves artistic quality concerns, and problem seriousness. Organizational characteristics that may influence scanning, interpreting, and responding to problems include organizational age and size.

In developing a model of the stakeholder-management process, I try to avoid making moral judgments. My purpose is to offer an accurate description of the factors influencing organizational relationships with stakeholders. Some practices and influences on organizational leaders' choices of practices may be viewed by the reader as more ethical than others. Many of the leaders themselves acknowledged the moral nature of their actions. Stakeholder-management practices undoubtedly reflect the leaders "occupational ethics" or "moral rules-in-use" (Jackal, 1988). By learning how leaders actually perform and evaluate their stakeholder-management activities we gain a greater understanding of the ethical demands of organizational stewardship. However, this book makes no attempt to differentiate leaders or actions according to their ethical character.

Influence of Stakeholder Importance on Responses to Problems

Organizations do not need the support of all their stakeholders to survive and prosper; the support of a coalition of stakeholders controlling the organization's most critical resources is sufficient (Pfeffer & Salancik, 1978.) The importance of a stakeholder to an organization depends on organizational leaders' interpretation of the attributes of the resources controlled by the stakeholder. Resources, and thus a stakeholder controlling the resources, can be ranked in importance by whether leaders interpret the resources to be needed for an organization to survive, needed to maintain an organization at existing levels, or needed for an organization to grow. When an organization's survival is in question, leaders consider the most important stakeholders to be those who appear to control resources needed for survival. When leaders know alternate sources of a resource exist, the importance of any one source to their organization is diminished (Thompson, 1967).

Leaders interact with stakeholders controlling resources based on the perceived predictability of gaining the resources from the stakeholders and the extent to which leaders believe their organization must give up stability and control to attract resources from those stakeholders. Leaders not only want to gain resources, they also want to gain and maintain as much freedom, stability, and predictability for their organization as possible (Bozeman & Straussman, 1983). These objectives affect organizational relationships with stakeholders and lead to the following predictions about stakeholder importance and responses to problems.

When organizational leaders believe a stakeholder is important to their organization, the leaders are likely to respond in ways that support the continuation of the organization's relationship with the stakeholder. Ending the relationship severs the flow of resources from the stakeholder to the organization. Therefore, leaders are unlikely to respond to important stakeholders by cutting or weakening ties to them. Stakeholders who do not control important resources are more likely to have their ties weakened or cut.

An organization is more likely to adapt or compromise in response to more important stakeholders than in response to less important ones. Adaptation and compromise improve congruence between an organization and stakeholder. When congruence improves, the probability increases that a stakeholder will provide resources. The proposed relationships between stakeholder importance and the adaptation and compromise responses are consistent with Oliver's (1991) prediction that managers are most likely to acquiesce or compromise in response to institutional pressures exerted by stakeholders on whom their organization is most dependent for resources.

Leaders are more likely to misrepresent or conceal information with less important stakeholders than with more important stakeholders. Individuals dislike and respond negatively to deceit (Kanter & Mirvis, 1989; Baron, 1988; Goldner, Ritti & Ference, 1977). If stakeholders interpret an organization's response as deceitful, they may withdraw resources from the organization. If a stakeholder accuses an organization of misrepresentation or withhold-

ing information, leaders can respond with additional misrepresentation (Brunsson, 1989), but this is a risky strategy. For example, if a stakeholder accuses leaders of misrepresenting an organization's financial condition, the leaders may deny the accusation and provide doctored documentation supporting the financial misrepresentation. However, the more complex the web of concealment and misrepresentations, the more difficulty leaders will have in managing the deceit without discovery. With each new deceit, there is an additional weak spot vulnerable to investigation by a stakeholder or to an inadvertent slip-up by the leaders. The cases of enterprises supported by falsified information that eventually collapsed demonstrate this dynamic (Gandossy, 1985). Because leaders are less likely to risk losing support from more important stakeholders than less important ones, leaders are less likely to conceal or misrepresent information when communicating with their more important stakeholders than with their less important ones.

Influence of Stakeholder's Decision-Making Authority on Responses to Problems

Organizational leaders' interpretation of a stakeholder's decision-making role within an organization also may help to predict responses. Some stakeholders have formal authority to influence organizational decisions. Those with authority power in an organization are likely to have their demands met by other members of the organization because the members believe those with formal authority have the right to decide the course of the organization (Astley & Sachdeva, 1984).

Stakeholders likely to be considered by organizational leaders to have formal decision-making authority are members of the board of directors, the executive director, volunteer managers, and staff managers. The board of directors is formally responsible for overseeing and setting the strategic direction for an organization and therefore has the greatest formal decision-making authority in an organization. Individual board members, by virtue of their position on the board, may be considered to have formal decision-making authority. The executive director typically is in charge of all routine operations and involved with the board in setting organizational policies. An artistic director usually has authority over the delivery of artistic products. Volunteer and staff managers usually have authority to manage their subordinates and coordinate the performance of tasks within their technical units. External stakeholders, such as clients, donors, and media representatives have no formal authority associated with these positions.

When individuals join an organization as board members, directors, or managers of volunteers and staff, they are given responsibility to influence the purposes, activities, and outcomes of the organization. Board members, in particular, are given the right to make demands because of their governance positions in organizations (Astley & Sachdeva, 1984). Once inside the organization, stakeholders have access to other influential internal stake-

holders who can be persuaded to form a coalition to promote their viewpoints. The greater authority, responsibility, and access of stakeholders with decision-making roles may give them a lobbying advantage. Therefore, organizational leaders are more likely to adapt an organization in response to problems with stakeholders who have formal decision-making roles than in response to problems with stakeholders who do not have formal decision-making roles.

Still, leaders have greater access and ability to influence internal stakeholders than external ones. Leaders can encourage the psychological tendency for stakeholders with decision-making authority to increase their support for and commitment to an organization (Salancik, 1977). Conformity influences and pressures to cooperate from other members of their organizations also may induce internal stakeholders to change their values, norms, and activities. (Pfeffer & Salancik, 1978). Given this reverse-influence dynamic, compromising and attempting to change a stakeholder are more likely responses for problems involving stakeholders with decision-making roles in an organization than for problems involving stakeholders without decision-making roles.

Influence of Stakeholder's Information on Responses to Problems

One of the most important tasks of leaders is to explain organizational actions and outcomes to stakeholders (Pfeffer, 1981). The performance of this task is influenced by leaders' preference for stakeholders to have favorable rather than negative impressions of their organizations. Leaders manage information flows and content to manipulate these impressions. The information about an organization that a stakeholder has available from other sources is relevant to leaders because it helps the leaders to determine what information they should provide the stakeholder. How much information leaders provide to a stakeholder and how clear and accurate the information is, may depend on the leaders' perception of what information the stakeholder has and can get from other sources.

The risk of a misrepresentation being uncovered by a stakeholder increases when the stakeholder has information on an organization that is not controlled by organizational leaders. The stakeholder may then identify inconsistencies in different sources of information. Much of the literature on misrepresentation (for example, Brunsson, 1989), emphasizes the importance of carefully controlling information flows to stakeholders to ensure desired impressions. If stakeholders have greater access to information unfiltered or altered by organizational leaders, they may learn unfavorable facts that the leaders prefer to keep hidden, such as earlier deceptions. Stakeholders do not want to be deceived and may withdraw resources from an organization if they discover information withheld or misrepresented by leaders. Therefore, leaders are more likely to use misrepresentation or concealment in response to problems with stakeholders who seem to have only controlled information

than with stakeholders that the leaders believe have sources of information not controlled by the leaders.

Influence of Stakeholder's Interaction on Responses

Individuals working within an organization (paid staff, volunteers, and board members) may try to influence responses to problems on behalf of stakeholders. Workers who frequently interact with external stakeholders are likely to have compatible backgrounds, attitudes, and training with the stakeholders (Scott, 1987). Through repeated social interaction, individuals come to think alike (Pfeffer & Salancik, 1978), develop positive sentiments for one another (Homans, 1950), and reduce their potential for conflict (Nelson, 1989). With more interaction, individuals are more likely to understand and respect one another's interests and to share one another's values and norms.

Depending on the extent of their power and interests, workers can encourage their preferred responses to a stakeholder through autocratic, bureaucratic, technocratic, or democratic arguments (Morgan, 1986). In other words, a worker may argue that a stakeholder should be responded to in a certain way because the worker says so, because the rules say it should be done that way, out of technical necessity, or because most workers would like it that way. Workers also may act on a stakeholder's behalf with judicious use of avoidance, compromise, accommodation and collaboration with other workers (Thomas, 1976).

The extent to which workers can influence responses to stakeholders depends on their power in their organizations. Workers with decision-making authority have power as do workers who cope with uncertainty, perform tasks that are nonsubstitutable and connected to other workers' tasks, and control activities influencing important organizational outcomes (Hickson et al., 1977). The more leaders believe that workers have values congruent with their own, the more they will permit and allocate power to those workers (Enz, 1988). Workers' power also is dependent on the level of institutionalization of their roles and supporting structures (Meyer & Scott, 1983). Even if other workers become more important to their organization's smooth functioning and survival, workers may be well-entrenched, retaining their ability to influence responses. Structures for interacting with stakeholders may exist long after their economic utility is past (Meyer & Scott, 1983), leaving particular organizational workers with control over relations with particular stakeholders.

We are likely to see more adaptation and compromise in response to problems involving stakeholders with stronger connections to more powerful organizational workers. More powerful workers have greater discretion than less powerful workers to act on behalf of stakeholders without the approval or knowledge of other workers in the organization. They also have greater ability than less powerful workers to obtain needed support from other workers. Therefore, adaptation and compromise are more likely to occur in response to a stake-

holder who interacts more frequently and with more powerful workers in the organization than in response to a stakeholder who interacts less frequently and with less powerful organizational workers.

Workers are unlikely to want to cut or weaken ties to stakeholders with whom they frequently interact. Not only may cutting or weakening ties be inconsistent with their values and loyalties, it may undermine their power in an organization. If ties are cut or weakened, the workers' responsibilities diminish and lose importance. To maintain their power within an organization, workers will try to maintain ties to the stakeholders with whom they interact. Therefore, cutting or weakening ties is less likely to occur in response to a problem with a stakeholder who interacts more frequently with more powerful organizational workers, than in response to a stakeholder who interacts less frequently and with less powerful organizational workers.

Influence of a Mission Threat on Responses to Problems

A mission is an organization's stated purpose, its reason for existing (Koteen, 1989). The organizations in this study explicitly defined their missions in order to obtain 501(c)(3) status (legal recognition as one type of nonprofit organization eligible to receive tax-deductible contributions and tax exemptions). To retain 501(c)(3) status, a majority of an organization's activities must be related to its mission. Aside from financial and legal considerations, an organization's mission is tied to its core identity and the type and level of support that it can attract from stakeholders. Nonprofit leaders are expected to keep their organization's mission in mind whenever they are making decisions on behalf of their organization. Many nonprofit management texts emphasize the importance of keeping mission as the foremost action guide (Brinkerhoff, 1994; Smith, Bucklin, & Associates, 1994; Drucker, 1990).

Some of the problems in the study involve situations in which a stakeholder is undermining an organization's mission. A stakeholder may ask an organization to change its mission or act in a way that harms the mission. Or stakeholders may erode or dilute the mission by diverting attention and resources away from mission-related activities. They may act in ways that contradict the values embedded in the mission, for example, by treating their participation in a theatrical production not as a serious artistic endeavor but as a device for personal amusement.

Stakeholders are linked to nonprofit organizations for a variety of reasons. Not all stakeholders are likely to be committed to the mission of the organization. As one director noted about the volunteers associated with his organization:

> It's easy for a volunteer or group of volunteers to get totally absorbed in a particular project, whether it's a bake sale or ball or whatever, some fundraising project, to

get so absorbed in that, that the project becomes in their eyes all-important. And the concerts you're giving and the mission of your orchestra that they're doing this project to support becomes secondary. And in fact it isn't unusual for people to be involved on a volunteer basis out of motivation that has nothing to do with the mission of the organization. It could be social motivation, could be upwardly mobile motivation, it could be all kinds of agenda for being involved in things.

These different agendas may influence the purposes, activities, and outcomes of the organization. Incremental changes to missions that have or might result from these agendas are less likely to be noticed by leaders than more radical changes. A slight shift of clients or service area might occur without thought about what it means to an organizational mission. Many mission statements are vague and can accommodate a variety of activities and outcomes without raising any warning signals. However, when leaders perceive that a problem with a stakeholder did or may significantly erode or divert their organization's mission, the leaders are likely to be more attentive to the problem and respond in predictable ways.

Organizational leaders are unlikely to adapt their organizations in response to stakeholders who appear to be threatening their missions. Hannan & Freeman (1989) argue that changes to an organization's mission undermine the organization's legitimacy with external stakeholders. Changing a mission in response to a problem with one stakeholder may create problems with other stakeholders. These other stakeholders may interpret a mission change as indicating that an organization's leaders lack commitment or are too responsive to political or economic forces. A mission change also may be inconsistent with the majority of stakeholders' values. For example, many volunteers join nonprofit organizations because they value what the organizations are trying to accomplish, as well as for the satisfaction of personal needs (Lauffer & Gorodezky, 1977). If the mission changes, the volunteers' commitment to the organization is likely to change. Executives of corporations and foundations fund nonprofit organizations based on whether the organizations' missions are consistent with the executives' values and interests. If the mission significantly shifts, support may be discontinued.

Also, leaders are unlikely to adapt their organizations' missions because of personal commitment to the missions. An organizational mission has three of four characteristics that have been shown to build commitment (Salancik, 1977). A mission is explicit, public, and a product of volition. Many nonprofit leaders regularly provide formal and detailed mission statements to funding sources, regulators, staff, and volunteers. Their missions are explicit and public. The characteristic of volition is satisfied because, in most cases, leaders play an active role in determining their organizations' missions. Irrevocability is the fourth commitment-building characteristic, and the one that is not satisfied by a mission. The mission is revocable through action of an organization's board of directors. Because leaders are likely to be committed to their organizations' missions, they are likely to resist a stakeholder's at-

tempt to change the mission or have the organization act in a manner that is incompatible with its mission.

Leaders also may find it difficult to change their organization's mission because it is at the core of their organization's identity and influences the distribution of resources within the organization (Hannan & Freeman, 1984). If an organization chooses to no longer offer a certain service, the staff and volunteers that provided that service lose power and resources within the organization unless they are transferred to an equally important service area. Members of organizations protect their interests and are likely to resist changes that may diminish their power. The classic cases of leaders changing missions, for example, The Young Men's Christian Association (Zald & Denton, 1963), are noteworthy for the effort and commitment required from organizational leaders and members, and for the strong environmental forces that encouraged the changes.

For all the above reasons, leaders are less likely to adapt their organizations in response to stakeholders who threaten their organization's mission, and are more likely to adapt their organizations when the adaptation does not involve a mission change. Confronted with a stakeholder who is threatening their mission, organizational leaders are likely to try to buffer their organization from the stakeholder's influence. To protect the organization's identity and preserve the status quo, the stakeholder's ties to the organization are likely to be cut or weakened. When a stakeholder is not threatening the organization's mission, there is less motivation to diminish the stakeholder's influence.

Influence of Artistic Quality Concerns on Response to Problems

Nonprofit scholars repeatedly have cited the need to address institutional context in exploring research questions related to the operations of nonprofit organizations (for example, Klaussen, 1995; Gronbjerg, 1993). One of the distinctive features shared by the organizations in my study is their nature as arts providers. The organizations offer nontangible products and services. Artistic quality of products and services is difficult for leaders and stakeholders to objectively assess because the definition of art, let alone "good" art, is problematic, dynamic, and contentious (Blau, 1989; DiMaggio, 1986). Organizational leaders and stakeholders may lack strong values and norms for determining what is good art and how it should be produced. The authority to decide what is art traditionally resides with intellectual experts or the power elite, such as art critics and curators of well-respected institutions, major artistic philanthropists, and highly successful fine artists (Banfield, 1984). Individual organizations rarely have the credibility to successfully proclaim artistic judgments concerning contentious art subjects unless they are very large, very old, and very well-respected in the particular artistic domain under attack. This is not the case for any of the organizations in my study.

Artistic quality issues raised by organizational leaders or stakeholders are likely to be associated with legitimacy problems in contrast to interest clashes. Differences over whether an outcome is good art does not involve technical efficiencies or economies. It involves questions of values and norms (Blau, 1989). To be able to capture any variation in responses because of problems involving artistic concerns over and beyond legitimacy concerns, I control for artistic quality concerns in my model of stakeholder management.

Influence of Organizational Age on Responses to Problems

Organizational age is a traditional predictor of organizational outcomes. Scholars have linked age to greater confidence of managers (Hambrick & Finckelstein, 1987), organizational routinization (Hannan & Freeman, 1984), and pressures for maintaining the status quo (Aldrich & Auster, 1986). Age also is associated with organizations having denser networks of stakeholders and leaders having greater knowledge of their environments (Hannan & Freeman, 1984). Therefore, age appears to be a promising predictor of responses to problems with stakeholders.

The older an organization, the less likely it will adapt in response to a problem with a stakeholder. Organizational age corresponds with leaders' confidence in their organizations' current strategies, structures, and systems. Therefore, leaders of older organizations tend to rely on the status quo (Hambrick & Finckelstein, 1987). Use of standard operating procedures constrains how managers interpret and respond to their environments (Hambrick & Finckelstein, 1987; Aldrich & Auster, 1986; Cyert & March, 1963). Over time there are greater investments in relationships and interests, and more extensive routinization of interactions. These investments and routinizations strengthen structural inertia (Hannan & Freeman, 1984) and pressures for internal consistency (Aldrich & Auster, 1986) and thus inhibit adaptation.

I expect the negative relationship between organizational age and adaptation to be especially strong for organizational legitimacy problems. Leaders of older organizations are less concerned than leaders of younger organizations about stakeholders' interpretations of their organizations' legitimacy (Singh, Tucker & House, 1986). Smith and Shen (1996) demonstrate that greater age is associated with higher ratings of reputational effectiveness of volunteer-managed nonprofit organizations. Over time, organizations develop greater resource reserves, denser exchange networks, and more political collateral, making them less vulnerable to legitimacy threats. Thus, older organizations have an "aura of inevitability" unavailable to younger organizations (Hannan & Freeman, 1984). They also have survived the intensive weeding-out process that young organizations face as part of the "liability of newness" (Stinchcombe, 1965). The extent that organizational vulnerability decreases with age may depend on the institutional domain. Bielefeld (1994) found that nonprofit organizations in the cultural industry did not gain a survival advantage with age.

Older organizations may have denser networks with stakeholders and have had more time to develop skills, knowledge, trust, and smoother working relationships with stakeholders (Hannan & Freeman, 1984). The greater knowledge of stakeholders and development of skills, trust, structures, and routines that come with a longer history of interaction with stakeholders enhances organizational leaders' ability to change stakeholders' values, norms, activities, or outcomes. Over time, leaders have the opportunity to develop and practice persuasion techniques and can use their established legitimacy with stakeholders to reinforce the credibility of their argument that stakeholders should change. Therefore, I expect more attempts to change stakeholders by leaders of older organizations than by leaders of younger organizations.

Influence of Organizational Size on Responses to Problems

Scholars have long argued that organizational size as well as age influences organizational actions. Unlike the operationalization of age, the operationalization of size varies greatly among studies. Following the dominant treatment in the literature, I consider size in terms of workforce. Greater size of an organization, as well as greater age, decreases the likelihood of organizational adaptation (Hannan & Freeman, 1984). Larger organizations have a greater core of activities and practices that leaders are likely to try to insulate from environmental forces to improve organizational stability (Hambrick & Finkelstein, 1987). Once insulated, there is a strong tendency for structural inertia in these elements (Hambrick & Finkelstein 1987, Meyer & Rowan, 1977). Also, larger organizations have longer chains of delegation. These longer chains slow and inhibit the process of adaptation (Hannan & Freeman, 1984). In larger organizations more individuals must accept a change and act to encourage or at least not interfere with its implementation for the change to be successful. Therefore leaders of larger organizations are less likely to use adaptation than leaders of smaller organizations.

Influence of Problem Seriousness on Responses

Organizational leaders' interpretation of the seriousness of a problem may influence their choice of response. Leaders act in anticipation of potential outcomes, preferring positive outcomes to negative ones. If leaders believe that their organizations will not suffer harm or lose important benefits if they do not respond to a problem, the leaders are unlikely to respond. Leaders' capacity to search and attend to problems is limited, and they will search for problems only up to the point where the marginal costs of the search appear to equal the marginal expected return from the search (Cyert & March, 1963). Similarly, leaders will

respond to a problem when the perceived benefits of responding outweigh or are equal to the perceived costs. Different responses have different costs and benefits associated with them.

Examples of possible costs are organizational effort and finances expended, lowered employee morale, and loss of stakeholders' support by not responding or responding in a way that does not satisfy the stakeholders. Possible benefits include legitimacy and resources gained by satisfying a stakeholder involved in a problem and pleasing other stakeholders likely to be affected by the response. The costs and benefits vary case by case. The higher the perceived costs and benefits to an organization, the more serious a leader will consider a problem to be.

By considering leaders' interpretation of the seriousness of a problem in developing a model of the management of stakeholder problems, we can explore whether certain responses tend to be used for more serious problems and other responses for less serious ones. However, the costs and benefits involved in responding to a problem are likely to vary among and within the response types. For example, revising public relations materials to fit media requirements is a less complex and costly adaptation than restructuring program activities in response to funders' concerns about duplication of efforts. In some situations compromising may be less costly than adapting; in other situations, the reverse may be true. Therefore, I do not have specific hypotheses regarding how problem seriousness affects choice of response.

I also do not develop specific hypotheses concerning how problem seriousness may interact with other predictors to influence responses. Depending on the seriousness of a problem, other predictors may be given more or less weight. For example, when a problem is more serious, leaders may be more cautious about using misrepresentation if stakeholders have information that is not controlled by the leaders. Also, judgments of problem seriousness may be influenced by other predictors, such as, stakeholder importance. The potential costs to an organization of not successfully managing a problem may be perceived as greater if a stakeholder controls more important resources than if the stakeholder does not have control over resources.

Summary of Hypotheses

Below is a summary of the hypotheses argued above, organized by response instead of predictor.

Adapt

Adaptation is more likely to occur when stakeholders involved in problems are interpreted by leaders to be more rather than less important. Adaptation also is more likely

in response to stakeholders with greater decision-making authority than in response to stakeholders with less decision-making authority. Stakeholders who interact frequently with powerful organizational members are more likely to be able to induce adaptation responses than stakeholders with weaker interactions with an organization. Adaptation will more likely occur when stakeholders do not threaten mission. Leaders of younger and smaller organizations are more likely to use adaptation responses than leaders of older and larger organizations.

Compromise

Leaders are more likely to compromise with stakeholders that they interpret to be more important to their organizations than with stakeholders they interpret to be less important. Leaders also are more likely to compromise with stakeholders with more decision-making authority than with stakeholders with less authority. Leaders are more likely to compromise with stakeholders who interact frequently with powerful organizational members than with stakeholders who do not.

Attempt to Change a Stakeholder

Leaders are more likely to try to change stakeholders' values, norms, activities, or outcomes when stakeholders have more rather than less decision-making authority in their organizations. Leaders of older organizations are more likely to try to change stakeholders than leaders of younger organizations.

Cut or Weaken Ties

Leaders are more likely to cut or weaken ties to stakeholders that the leaders interpret to be less important to their organizations than to cut or weaken ties to stakeholders that they interpret to be more important to their organizations. Leaders also are less likely to cut or weaken ties to stakeholders with whom powerful organizational members more frequently interact than to cut or weaken ties to stakeholders who interact less frequently and interact with less powerful organizational members. Leaders are more likely to cut or weaken ties when their organization's mission is threatened than when the mission is not threatened by a problem with a stakeholder.

Misrepresent or Conceal Information

Leaders are less likely to misrepresent or conceal information when stakeholders are considered to be more important than when stakeholders are seen as less important. Leaders also are less likely to use misrepresentation or concealment with stakeholders that the leaders believe have information sources not controlled by the leaders than with stakeholders that they believe do not have alternative sources of information.

The Scanning, Interpreting, and Responding Process

I have described a variety of possible influences on responses to problems with stakeholders. These influences may emerge during the process of scanning, interpreting, and responding. This process has been described by Daft and Weick (1984) and Milliken (1990) to encompass leaders' identification of changes in their organization's environment, interpretation of the meaning and significance of the changes and response options, and evaluation of the utility of the options. The scanning, interpreting, and responding model assumes a link between rational thought and action but allows for politics, biases and routines to interfere with the understanding of events and the rational selection of responses (Thomas, Clark, & Gioia, 1993).

During the scanning phase leaders search an organization's external and internal environments for potentially important events or issues. Some of the organizational, stakeholder, and problem characteristics described earlier in the chapter may influence scanning activities. For example, leaders may be more likely to search for problems associated with their more important stakeholders than less important stakeholders. Because an individual's ability to search and attend to information is limited, and searches are conducted based on perceived costs and benefits, leaders' attention is most likely to be focused in areas that are perceived to offer the most useful and relevant data.

Because of their greater access to leaders and personal involvement in scanning practices, internal stakeholders and stakeholders with decision-making roles may have an advantage in making leaders aware of problems involving them or stakeholders interacting with them. Leaders may be more likely to pay attention to information from stakeholders with decision-making authority or organizational workers. Information presented from other sources less familiar to the leaders may be filtered out because it appears less relevant, arrives through nonconventional channels, or requires more work to obtain. On the other hand, information from nonroutine sources that catches the attention of leaders may receive more serious consideration.

Once information becomes salient to leaders, they need to make sense of it. The interpreting phase involves comprehending the meaning and significance of information gathered during scanning. Characteristics of the organization, stakeholder, and problem may combine to influence leaders' identification and understanding of a problem, options available to respond to the problem, and the utility of the options. The influences may be direct (as developed in the hypotheses), indirect, or interacting.

During the responding phase, leaders act based on their interpretations of a problem and organizational options. Responding, or "learning" to use Daft and Weick's (1984) term, involves acting according to what the leaders believe to be the best response. Feedback from stakeholders after the organization has acted may be scanned, interpreted, and lead to additional responses.

The management of problems with stakeholders incorporates all three phases of scanning, interpreting, and learning. It is best viewed as a dynamic process. Although this book cannot provide detailed histories of each of the problems examined in this study, vignettes and quotes offer a flavor of the ongoing nature of relationships with stakeholders. The sometimes long history of problems was emphasized by a director whose organization suffered from a power struggle with a board member. She said:

> There are board members that seem to be, they are stones, we call them stones. They're there to hold things back, to be a weight, not positive or visionary. They have their own little agenda. The problem [we had] with a board member was an internal conflict that probably was more damaging to the organization than any of the external ones. It took years to undo it.

Many problems require a series of responses based on feedback from stakeholders. Problems are rarely completely resolved. The issues that underlie them often arise again and receive further attention.

Summary

This chapter presented a model of the management of problems with stakeholders. A variety of characteristics of stakeholders, problems, and organizations were developed as potential predictors of responses to problems. Leaders' responses to problems were considered to be outcomes of a scanning, interpreting, and responding process. This process describes how leaders generally make sense of problematic changes in their relationships with stakeholders and try to manage the changes. The next chapter begins the presentation of the study findings.

Appendix A describes the research methodology, including measurements of the variables. The appendix also provides details on the organizations that participated in the study. Although it is not necessary to read the appendix to understand the results of the hypothesis tests and exploratory analyses, readers may wish to review the appendix before proceeding to the next chapter.

3

FINDING PATTERNS IN THE MANAGEMENT OF PROBLEMS

This chapter shows how characteristics of an organization, its stakeholders, and problems combine to influence organizational actions. First I examine the combination of responses that are used to manage problems. Then I search for relationships among the predictors. Next I turn to tests of the hypotheses, looking at each potential response to a problem and examining the factors associated with its use. These analyses sometimes serve as a jumping-off point for discussion of patterns revealed in the interviews but not reflected in the statistical analyses. At the end of the chapter, I present findings regarding leaders' and stakeholders' satisfaction with organizational responses. From these analyses, a refined picture of stakeholder management emerges.

Correlations among the Responses

Although I approached each response independently in my development of hypotheses, it is misleading to treat the responses as exclusionary options. Leaders may implement one or more of the responses as a way to manage a problem with a stakeholder The responses may be used simultaneously or sequentially. Table 3.1 shows the correlations among the use of responses reported by directors. Some responses rarely were used with other responses. Others had common partners.

There were two sets of responses that tended to be used together: 1) compromising and trying to change a stakeholder, and 2) misrepresenting and cutting or weakening ties. Many of the compromises were initiated by the leaders of the organizations studied. In order to persuade stakeholders to negotiate compromises, the leaders often tried to change the stakeholders' understandings, values, or norms regarding a problem. In some cases involving compromises, stakeholders were initially unaware that they were creating problems for an organization. For example, sometimes organizational leaders had to point out the negative consequences of competition before other arts organizations agreed to coordinate scheduling of activities.

TABLE 3.1
Correlations of Responses

N=83

Variables	1	2	3	4	5
1. Adapt Organization	1.00				
2. Compromise with Stakeholder	.051 p=.65	1.00			
3. Try to Change Stakeholder's Understandings, Values, or Norms	-.075 p=.50	.217 p=.05	1.00		
4. Cut or Weaken Ties to Stakeholder	-.186 p=.09	.051 p=.65	-.075 p=.50	1.00	
5. Misrepresent Organization to Stakeholder	-.083 p=.46	-.170 p=.12	-.366 p=.001	.236 p=.03	1.00

Notes:
1. The p-values shown in this chapter are a measure of the significance of the relationship being examined. P-values of .10 or less are generally considered to be statistically significant and permit drawing inferences from the data.
2. The p-values shown in Tables 3.1, 3.2, and 3.9 are two-tail significance levels, which is appropriate given that the tables are not testing uni-directional hypotheses.

The explanation for the positive relationship between use of misrepresenting and cutting or weakening ties becomes clear when we examine the types of misrepresentations used when ties are diminished. Most of the misrepresentations help minimize the possibility that stakeholders are offended by having their influence over an organization reduced. Other misrepresentations are attempts to prevent political battles, as illustrated by a comment by a director who secretly arranged to have a board member with unpopular opinions isolated from decision making on important issues. In discussing the value of avoiding personal confrontations, he stated, "What you can do—whether it's back-dooring, or whatever you want to call it—what it can do to avoid confrontation in dealing with the situation is probably in most cases desirable."

One director explained how her organization used both misrepresenting and cutting ties responses simultaneously to encourage artists who were not meeting new quality standards to quit. Quality was never raised as an issue. In fact the new standards were never explicitly presented to the artists. Instead, performances requiring greater technical skills were scheduled, fewer rehearsals were offered, and preparation time before performances was shortened. The process was carefully designed to encourage the artists to believe that they were making the choice to leave the organization. The director stated:

We did it in a way so that whenever someone left, they were recognized for their contributions. I sent them a personal letter thanking them and sent them tickets for the next season to make sure they came back, continued to be a friend of the organization. Not only did we eliminate a great confrontation, letters to the editor, etc., we also made friends of people who could potentially be serious enemies. And we honored people for what their rightful contribution was.

There were two sets of responses that had a significant negative relationship: 1) adapting an organization and cutting or weakening ties, and 2) trying to change a stakeholder and misrepresenting. If it was possible and worthwhile for an organization to adapt to be more congruent with a stakeholder, there would be little benefit in also cutting or weakening ties to the stakeholder. There is a greater long-term benefit from leaders expending resources to adapt their organization in response to a problem with a stakeholder if the leaders hope to maintain rather than diminish the stakeholder's relationship with their organization.

The finding that trying to change a stakeholder and misrepresenting rarely are combined is partially an artifact of the coding protocol. The misrepresenting response is defined as an attempt to change a stakeholder's understanding by withholding information or offering incorrect or hypocritical information. In contrast, the changing stakeholder's response is defined as an attempt to change a stakeholder's values, norms, or understandings without using misrepresentation. The change may be coerced or encouraged through reframing a situation, offering persuasive arguments, or triggering latent values or norms. In a few cases leaders used the two responses sequentially, but in most cases they were either consistently honest and open in their dealings with a stakeholder or dishonest and closed. Misrepresentation occurred primarily when leaders wanted issues buried or disguised, not when they wanted issues brought out into the open and at least temporarily resolved.

Correlations among the Predictors

Table 3.2 presents the correlations among the predictors. Understanding the relationships among the predictors is important in helping design the regression models used in testing hypotheses and in interpreting the results of the tests. Appendix B presents the correlations of the predictors with the responses.

The stakeholders in the problem situations share similar characteristics. If a stakeholder was rated high on decision-making authority, he or she also was likely to be rated high on information access and interaction with workers. This is because a stakeholder with high decision-making authority is likely to be an internal stakeholder, perhaps a board member or staff manager with several information sources and points of contact with an organization. The high multicollinearity of the three predictors (stakeholder decision-making authority, information access, and interaction) makes it difficult to determine their relative

TABLE 3.2
Correlations of Independent Variables

N=83

Variables	1	2	3	4	5	6	7	8	9	10	11	12
1. Stakeholder Resource Importance	1.00											
2. Stakeholder Decision-making Authority	.332 p=.002	1.00										
3. Stakeholder Interaction	.353 p=.001	.712 p=.000	1.00									
4. Stakeholder Information	.346 p=.001	.715 p=.000	.588 p=.000	1.00								
5. Age of Organization (logged)	.137 p=.217	.324 p=.003	.192 p=.082	.148 p=.183	1.00							
6. Size of Organization (logged)	.067 p=.548	.141 p=.205	-.020 p=.859	.057 p=.610	.514 p=.000	1.00						
7. Problem Seriousness	.355 p=.001	.352 p=.001	.462 p=.000	.269 p=.014	.100 p=.369	.064 p=.564	1.00					
8. Stakeholder Legitimacy Problem	-.103 p=.356	.061 p=.583	.039 p=.729	.089 p=.424	-.206 p=.062	-.134 p=.227	-.150 p=.176	1.00				
9. Organizational Legitimacy Problem	.056 p=.613	-.044 p=.694	-.057 p=.607	-.057 p=.608	.140 p=.207	.112 p=.313	.089 p=.424	-.467 p=.000	1.00			
10. Interest Clash	.049 p=.662	-.019 p=.863	.016 p=.887	-.034 p=.758	.072 p=.516	.027 p=.808	.065 p=.559	-.551 p=.000	-.480 p=.000	1.00		
11. Mission Threat	-.117 p=.293	-.084 p=.451	-.085 p=.443	-.125 p=.262	-.125 p=.259	-.036 p=.748	.059 p=.598	-.177 p=.110	.262 p=.017	-.072 p=.517	1.00	
12. Artistic Quality Issue	-.061 p=.584	-.041 p=.713	-.012 p=.917	-.204 p=.064	.104 p=.350	-.051 p=.644	.094 p=.400	-.014 p=.901	.342 p=.002	-.309 p=.004	.249 p=.023	1.00

importance when all three are used in a regression analysis. Therefore, I dropped stakeholder information access and interaction from the tests of the full models. In the regression analyses, stakeholder decision-making authority and stakeholder importance may capture some of the effects of a stakeholder having information and access.

Stakeholder decision-making authority and stakeholder resource importance also are highly correlated. Board members and staff managers often provide critical resources to their organizations. However, not all stakeholders providing important resources to an organization are internal stakeholders with decision-making authority and vice versa. I retain both stakeholder importance and decision-making authority in the regression models to see if the analyses demonstrate unique effects of these two stakeholder characteristics.

Stakeholder characteristics are associated with the perceived seriousness of a problem. The more a stakeholder controls important resources, the more serious the directors perceive a problem with the stakeholder to be. Stakeholders controlling needed resources may make more credible threats and demands because they can withdraw or withhold resources from an organization. Also, the greater a stakeholder's decision-making authority, the greater the perceived problem seriousness. Stakeholders with decision-making authority operate at the core of their organization. They have the knowledge and access to create disruptions in critical activities. They also serve as representatives of their organization to other stakeholders. As representatives, they influence stakeholders' judgments of their organization. Therefore when a problem involves them, leaders see the problem as more serious.

The extent to which a stakeholder controls resources or has authority is not significantly related to the types of problems they present. Legitimacy problems, interest clashes, mission threats, and artistic quality concerns are raised by stakeholders with and without resource control or authority. However, when we compare internal stakeholders to external ones, we see that internal stakeholders proportionally present more stakeholder legitimacy problems than external ones. External stakeholders are engaged proportionally in more interest clashes. Internal and external stakeholders are equally likely to raise organizational legitimacy problems. The breakdowns of the problem types by external versus internal stakeholder are provided in Table 3.3.

Not surprisingly, organizational age and size are highly correlated. The larger organizations in the study are also older. Because of this high multicollinearity, it is difficult to determine the importance of age and size in predicting responses when both variables are included in a regression analysis. Therefore, three regression analyses were performed for each response. One analysis includes both age and size in the model. A second analysis excludes the size variable and a third includes size but excludes age. Only the results of the first analysis are presented in this chapter. The other two analyses are included in Appendix C and discussed in this chapter only when they show that age or size has a significant influence on use of a response.

The age of an organization is associated with both stakeholder and problem characteristics. The older an organization, the more likely a problem involves a stakeholder with decision-making authority, such as a board or staff member, and the more likely the stakeholder

TABLE 3.3

**Number of Internal and External Stakeholders Involved
in Legitimacy Problems and Interest Clashes**

	Type of Stakeholder	
Type of Problem	External	Internal
Organizational Legitimacy Problem	12	12
Stakeholder Legitimacy Problem	10	19
Interest Clash	<u>19</u>	<u>11</u>
Column Total	41	42

Likelihood Ratio Chi-Square 4.99, df=2, p=.08

presents a stakeholder legitimacy problem. Younger organizations appear to face more problems finding a niche in their communities and developing smooth relationships with external stakeholders. When I asked one director of an arts center whether she ever felt the need to defend her organization to community members, she answered, "Not any more. There was a time when we were very young that we did, but we've been around eleven years now and they know who we are and what we're doing and why." Organizational age was not significantly related to frequency of reports of organizational legitimacy problems or interest clashes. Despite arguments that older organizations are less vulnerable to legitimacy threats than younger organizations (Singh, Tucker, & House, 1986), in this study directors of older organizations were just as likely to report stakeholders' disapproval as directors of younger organizations.

Characteristics of problems also are related. Organizational legitimacy problems tend to include mission threats and concerns about artistic quality. When a stakeholder challenged or undermined an organization's mission, the stakeholder tended to negatively evaluate the organization's legitimacy. This combination frequently occurred when stakeholders argued that some aspect of an organization's artistic purposes, activities, or outcomes is improper and should be changed, for example, an art exhibit including paintings of nudes. No problem in the sample was more than one problem type (organizational legitimacy, stakeholder legitimacy, or interest clash.) Because the three problem types are mutually exclusive, they are treated as a categorical variable in the analyses.

When Do Organizations Adapt in Response to Problems with Stakeholders?

Some aspect of an organization was changed in response to a problem with a stakeholder in 24 percent of the 83 problem cases. The adaptations include changes to organizational structures, policies, mission, and practices. In some cases these substantive changes are accompanied by changes in organizational values. For example, the board and music director

who changed a symphony orchestra's programming to include pops concerts first changed their valuation of movie music. Table 3.4 shows the results of a logistic regression testing influences on the use of adapting. The model does a good job predicting adaptation.

As expected, the more important directors perceive a stakeholder to be (based on the stakeholder's control of resources), the more likely their organizations are to adapt in response to a problem with the stakeholder. However, the resources that directors rate as most critical to their organizations are rarely financial in nature. Several directors expressed the view that any one funder could be replaced. The most important resources are the ones directly needed to fulfill missions.

For example, one director said one of her most important stakeholders provides transportation for her organization. When the director was caught between the transporter—who refused to take an exhibit to a particular site because of an earlier accident involving the transporter at the site—and the community that wanted the exhibit to visit, she accepted the transporter's decision. The community used letters to the editor and other vehicles to vent their dissatisfaction. The director reflected, "We could not have gone there [the community] without their [the transporter's] cooperation, and so we didn't in effect cancel—but our decision not to push any harder than we did was important and effective. We could have made a bad situation even worse and we didn't do that, although it's hard to know."

In some cases, leaders are less interested in preserving desirable flows of resources from a stakeholder directly involved in a problem situation than in preserving support from other stakeholders. One leader explained that her organization would not offer any new programs proposed by stakeholders that might turn off the general public that the organization looks to for funding. She said, "I can't offend them. I would be putting the organization in jeopardy to do that." Another director conveyed his fears about losing multiple sources of support because he was not appeasing one donor. He stated, "His [the donor's] letter to the editor about how we treated his donation could be very disastrous to us. If people read that and think poorly of the museum, they may think less about giving us their dollar, their items for our collections and so on. I'm not saying he's going to write a letter to the editor but that seems to be the way most people vent their grudges."

Some of the leaders indicated that it is not simply concerns about continuing a desirable flow of resources that drives their decisions to adapt. Many stated that they want to be accountable to the stakeholders who support their organization and are willing to change their organization in response to these stakeholders' interests and demands. It was a desire to be responsive to supporters that led to organizational changes rather than fear of losing needed resources. In fact, many organizations in the study adapted in response to problems with stakeholders who control important resources, even when adapting ultimately resulted in greater resource needs and uncertainties. One director said, "We've never had a request from the community for something that was not done. We haven't always made money on

it, but we do attempt to serve our community and keep the lines open." Another stated, "We have a membership of about 2,000 people, and I think that to the extent that they pay money to us every year, they are entitled to express their opinions about things in many ways. We are very sensitive to attitudes of our constituency." A director explained adoption of a policy requested by a stakeholder in terms of an obligation: "No, I would not have lost her support; I didn't do it because I was afraid of losing her. I did it because I felt it was her just desserts."

TABLE 3.4

Test of Model of Adapting Using Logistic Regression

Variables	B	Standard Error	Wald Statistic	Significance
Stakeholder Resource Importance	.488	.261	3.482	.06
Stakeholder Authority	.097	.240	.162	.69
Organization Age	-1.565	1.342	1.361	.24
Organization Size	-1.168	.857	1.858	.17
Mission Threat	-1.757	.934	3.538	.06
Artistic Quality Issue	-1.191	1.223	.947	.33
Problem Seriousness	.404	.357	1.282	.26
Problem Type			4.615	.10
Organizational Legitimacy	.920	.489	3.532	.06
Stakeholder Legitimacy	-1.051	.519	4.093	.04
Constant	2.837	2.501	1.286	.26

	Chi-Square	df	Significance
-2 Log Likelihood	71.203		n.s.
Model Chi-Square	28.23	9	.015
Model correctly classified	77.11 percent of cases		
N=83			

Notes:

1. Logistic regression is the appropriate statistical technique for the tests of hypotheses because the dependent variable (response to a problem) has only two values (occurred or did not occur.) A logistic coefficient is interpreted as a change in log odds associated with a one-unit change in the independent variable.

2. The predictive value of all the variables discussed in chapter two are tested for each response whether or not a hypothesis was associated with the variable. This allows for comparison of the usefulness of the predictors across different responses.

3. The -2 Log Likelihood compares the model to an ideal or perfect model. When this value is not significant (indicated as n.s.), the model does not differ significantly from a perfect model, showing that the tested model is good.

4. The Model Chi-Square is comparable to the overall F test in multiple regression. When the model is good, this statistic is significant.

When their missions are threatened, organizations are significantly less likely to adapt. Some of the directors emphasized their attempts to maintain the integrity of their missions. One director explained how he often rejects musicians' demands for changes in what they will perform and under what conditions. He stated:

We constantly contend with what the musicians perceive as their needs and re-
quirements that don't necessarily support, in fact, stand in the way of our goals,
our mission. What's best from an educational standpoint, what's best to serve the
constituency is all too often not what the musicians perceive to be in their best
interest. It is sometimes hard for musicians to understand that the organization
does not exist for them.

The type of problem faced by leaders also influences whether they adapt their organization's
purposes, activities or outcomes. If they are facing an organizational legitimacy problem,
they are more likely to adapt. The adaptations help improve the stakeholders' judgments of
their organization. If the problem involves low stakeholder legitimacy, the leaders are un-
likely to adapt their organization. Substantively adapting their own organization's purposes,
structures, or practices will not change their disapproval of a stakeholder.

Age and size do not appear to influence adaptation according to the analysis shown in
Table 3.4. However, when only one of the two predictors is included in the test of the
model, age and size are significant predictors. Appendix C, Tables C.1 and C.2, show the
analyses using each of the two variables without the other. The analyses indicate that younger
and smaller organizations adapt more than older and larger organizations. This finding is
consistent with traditional theoretical arguments that older and larger organizations tend to
maintain the status quo more than younger and smaller organizations. With age and size
comes greater inertia. Over time, managers develop greater confidence and vested interests
in current structures and practices. In my interviews, directors of younger organizations
expressed the most doubt about their community's acceptance and continued support of
their organizations. This may have contributed to their greater willingness to adapt when
pressured by stakeholders.

Internal stakeholders with decision-making authority do not have a significant advantage over
other stakeholders in having organizations adapt in response to problems with them. Contrary
to theoretical arguments, leaders' willingness to adapt to please stakeholders is not related to
stakeholders' authority. In deciding whether to adapt their organizations, the leaders in my study
rely more on analysis of stakeholders' rights, potential resource losses, and the guidance of their
organization's mission.

Part of the leaders' decision process is undoubtedly influenced by the common philoso-
phy that it is impossible to please everybody all of the time. The director of an arts center
stated, "I think we do have to understand that we can't be all things to all people." A theater
director noted, "We have this huge problem of everybody wanting us to be the theater that
they want to have. We opened the theater with a certain number of goals and it conflicts
with a tremendous number of personalities in the artistic community." A museum director
said, "Nobody is perfectly happy. That has always been my biggest challenge, to try and
make everybody think they are getting the best of the situation where in reality everybody

really is sharing the institution." An arts council director stated, "We at last know we can't be all things to all people." A symphony director stated, "No one's ever really happy. I mean, it seems like you can't keep everybody happy all the time." Recognizing this, leaders rarely expressed discomfort in refusing to meet some of their stakeholders' demands or not acting in all their stakeholders' interests.

When Do Organizations Compromise in Response to Problems with Stakeholders?

There are ten cases in the sample involving compromises (12 percent of the cases), making this response the least used. Perhaps it is less common because of the time and effort often required to negotiate and bargain with stakeholders. Table 3.5 shows the model for the compromising response. Two variables significantly explain when organizations compromise: stakeholder authority and problem seriousness.

TABLE 3.5
Test of Model of Compromising Using Logistic Regression

Variables	B	Standard Error	Wald Statistic	Significance
Stakeholder Resource Importance	-.140	.339	.171	.68
Stakeholder Authority	-.925	.469	3.890	.05
Organization Age	-.918	1.541	.355	.55
Organization Size	1.142	1.050	1.183	.28
Mission Threat	.681	.871	.611	.43
Artistic Quality Issue	1.370	1.076	1.622	.54
Problem Seriousness	1.293	.555	5.418	.02
Problem Type	1.223	.54		
Organizational Legitimacy	- .585	.658	.789	.37
Stakeholder Legitimacy	.578	.568	1.033	.31
Constant	-9.123	3.954	5.324	.02

	Chi-Square	df	Significance
-2 Log Likelihood	46.550		n.s.
Model Chi-Square	14.518	9	.105
Model correctly classified	87.95 percent of cases		
N=83			

Contrary to expectations, leaders rarely compromise with internal stakeholders with decision-making authority, such as board members and staff managers. They are more likely to compromise with external stakeholders who have no formal decision-making role in their organization. Most of the compromises involve what programming will be offered and when.

In two of the ten cases, compromises were the result of lawsuits brought by neighbors to restrict organizational activities. In most of the other cases, compromises were negotiated with other arts organizations to coordinate program design or delivery, or with patrons to balance conflicting interests.

Compromises tend to be used to manage more serious problems. When a problem has high benefits and costs associated with it, leaders invest the time and energy required to initiate or negotiate compromises with stakeholders. Still, a stakeholder's control of resources does not significantly influence use of compromises. The generally high ratings of the seriousness of problems resulting in compromises are not explained by the benefits and costs from maintaining or losing the support of a single stakeholder. Leaders did not compromise to ensure that a specific stakeholder would not withhold or withdraw important resources. Leaders compromised so that they could attract wider community interest and involvement. Most of the problems leading to compromises are serious because they have the potential to influence the long term viability and integrity of an organization through audience participation and satisfaction with programs.

One of the common threads in my interviews is the prevalence of compromises in programming decisions. Many of the directors expressed a general desire to maintain a programming balance that would please enough stakeholders to keep their organization financially viable, bring broad community involvement, and preserve their organization's identity as a provider of arts programs. To this end, programming decisions often balance the artistic sensibilities of organizational leaders with the artistic preferences of audience members and interests of funders. One director stated:

> We're never going to compromise our values completely and do some really bizarre thing, you know. But there are areas that you can bend a little bit one way to get the audience and get the money, yet we balance that by still maintaining the musical integrity and offering some straight classical pieces around that, so that it all balances out.

Another director discussed why she slipped more "broadening" works into ticket series programs that were mostly composed of "light" entertainment. She stated, " Everybody likes to be entertained, but we try to throw culture into it too. We spoon-feed culture; a lot of people reject it if you say this is a cultural event and you should attend. If you just don't say it and they attend, they say I never went to a symphony before, but it sounded pretty good."

Although many directors assumed that they knew what their target audiences wanted, others recognized that they needed to become more educated about potential and current audience interests. Programming was sometimes a hit or miss approach. As one director admitted:

There is always that nagging suspicion: Are we doing the right thing? Are we basing what we are doing on any kind of quantifiable evidence or is it just a gut feeling, or our aspiration, gee this would be a nice thing to do, so we'll have that program. Mostly, that is exactly what it is.

A large majority of the directors are conscientious about informally surveying what other arts organizations in their communities are doing. Other arts organizations were involved in 14 percent of the problem cases, ranking them at the top of the list of problematic stakeholders (see Table 1.1.) Avoiding the duplication of other arts organization's efforts was a top priority for the leaders. The directors of organizations with larger resource bases tended to try and provide programs beyond the scope of their less well-endowed colleagues. All the directors seemed conscious of the negative consequences of competition and expressed great frustration when their "turf" was invaded. Several argued that competition could be largely prevented if the leadership of both organizations were willing to compromise. The directors never discussed any attempts on their part to put another arts organization out of business, and several mentioned the benefits of collaborating. Some of the problems analyzed involve interest clashes and stakeholder legitimacy problems arising from attempts to collaborate.

A few of the directors are willing to compromise on the quality of their programming to keep their doors open. One director promoted his philosophy that quantity was more important than quality in maintaining visibility and support in a community. Discussing the role of financial constraints in influencing program choices and delivery, he stated:

I think there are some occasions where we've done things just the way we wanted to do it, and I look back on those occasions with a lot of pride. On the other occasions when we've compromised, I look back on those and say that was a step to get where we are today, and I take pride in that fact.

The directors vary in their willingness to design programs around funders' interests. Some agree with one director who said, "I don't build programs because they said they would fund something if we did this, or they said that turns me off." Others talked about their pleasure in matching their organization's artistic capabilities with interests of funders. One director described her desire to serve multiple agendas:

My vision is to address more programs in conjunction with basic human needs. For example, we had a grant to pay two professional artists to work with kids who were diagnosed as substance abusers or at risk to be, and this really was an art therapy project. The project was incredibly successful and we received super comments from the kids who participated. It was also more fundable to kill two birds with one stone. It was not just art for art's sake. Looking at how we're scrambling

for the same piece of the pie, the same dollars; that's my vision of the future, that we develop more of those kinds of partnerships.

When Do Organizational Leaders Try To Change Stakeholders?

Table 3.6 shows the logistic regression results for the model of the response of trying to change a stakeholder's understandings, values, or norms. The variables in the model do not do a good job in predicting the response. Trying to change stakeholders' understandings, values, or norms is used in 61 percent of the cases, making it the most common response to problems with stakeholders. As an all-purpose response, it is used for legitimacy problems and interest clashes, mission threats, and artistic quality concerns. The frequency of this response makes it appear that the leaders of the arts organizations in my study follow Pfeffer's (1981) prescription that the most important job of leaders is to interpret their organization to others.

The directors reported that simply explaining and justifying organizational perspectives, rules, and practices often resolved problems. This strategy is popular for both internal and external stakeholders. One director, faced with other organizations using a stage in a park without her organization's permission, stated, "Organizations knew after they'd spoken with

TABLE 3.6

Test of Model of Trying to Change Stakeholder's Understanding, Values, or Norms Using Logistic Regression

Variables	B	Standard Error	Wald Statistic	Significance
Stakeholder Resource Importance	.510	.200	6.518	.01
Stakeholder Authority	-.185	.215	.734	.39
Organization Age	-.088	.988	.008	.93
Organization Size	-.491	.708	.481	.49
Mission Threat	.447	.630	.505	.48
Artistic Quality Issue	-.688	.775	.787	.38
Problem Seriousness	.166	.295	.315	.57
Problem Type			.180	.91
Organizational Legitimacy	.046	.395	.014	.91
Stakeholder Legitimacy	-.148	.363	.166	.68
Constant	1.273	1.919	.440	.51

	Chi-Square	df	Significance
-2 Log Likelihood	99.308		n.s.
Model Chi-Square	11.366	9	.25
Model Correctly Classified	72.29 percent of cases		
N=83			

me that they were off on their decision-making, that they should not have done what they had done. It was simply a matter that they were not informed." Another director shared the view that many problems are the result of misunderstandings and unclear expectations. Discussing problems with volunteers not meeting performance standards, she said:

> I have the viewpoint that any of these things that are organizational problems from volunteers are never done in malice as far as I'm concerned. They've done it because they don't understand, they haven't been shown the big picture, it wasn't explained to them the bigger reasons, and I understand as volunteers they have certain limits. So I don't get real upset, I get frustrated sometimes and search for better ways to get things happening.

Sometimes directors patiently repeat the same explanations and justifications to the same stakeholders. For example, several directors noted that they had to keep reminding and convincing cosponsors and promoters to mention all the sponsors of events. The businesses who kept "forgetting" to give proper credit, were excused by some of the directors because "the nonprofit world is different from the profit world" and "a lot of times they don't understand. They never looked at it from that angle."

The only significant predictor of when organizations try to change stakeholders' understandings, values, or norms, is stakeholder importance. Because of the limited time available to "fight fires," leaders make choices concerning which problems to address and which to ignore. In cases in which a stakeholder does not offer any resources of value to their organization, leaders rarely try to persuade the stakeholder to change. For example, the director of one theater has a policy to ignore playwrights who send unsolicited scripts. Despite disgruntled playwrights who complain that the organization is rude or stole their ideas, the director believes it is not worth his organization's time to try and convince the playwrights that the theater is acting responsibly when it ignores their manuscripts. When the risk of losing needed resources is low, leaders are willing to take a "wait and see" attitude or to dismiss a stakeholder's dissatisfaction as "just too bad." Several directors expressed the view that some problems go away by themselves. If a stakeholder is not that important to an organization, leaders are less motivated to act.

When Do Organizations Cut or Weaken Ties to Stakeholders?

In 24 percent of the cases in the study, ties to a stakeholder were cut or weakened. Table 3.7 presents the logistic regression results for the model examining this response. The model does an excellent job in predicting cutting or weakening ties.

TABLE 3.7

Test of Model of Cutting or Weakening Ties Using Logistic Regression

Variables	B	Standard Error	Wald Statistic	Significance
Stakeholder Resource Importance	-1.333	.431	9.580	.002
Stakeholder Authority	.769	.381	4.064	.04
Organization Age	-.033	1.338	.001	.98
Organization Size	-1.581	1.093	2.090	.15
Mission Threat	1.730	1.031	2.818	.09
Artistic Quality Issue	-1.836	1.242	2.182	.14
Problem Seriousness	1.328	.487	7.444	.006
Problem Type	11.275	.004		
Organizational Legitimacy	-.901	.691	1.703	.19
Stakeholder Legitimacy	2.314	.690	11.234	.001
Constant	-4.506	2.571	3.072	.08

	Chi-Square	df	Significance
-2 Log Likelihood	48.058		n.s.
Model Chi-Square	43.605	9	.000
Model correctly classified	90.36 percent of cases		
N=83			

The model demonstrates that leaders protect their organizational missions. By reducing a stakeholder's influence, leaders may prevent or lessen the impact of attacks on their mission by the stakeholder. A founder of a theater recalled how he asked a board president to resign. He told the president, "This is not appropriate; you're forcing the company to go into areas, which are not part of the mission, and thank you for trying to bring all this money in here, but I'm losing sight of what I started [the company] for." A director of an arts center that presented art exhibitions in the lobby of a local business for several years reported that the center was willing to give up this important exhibition site when the business managers began demanding that certain types of artworks be censured. The center director refused to compromise the center's mission by allowing individuals with no art training to be involved in exhibition jurying.

The more decision-making authority a stakeholder has, the more likely leaders are to diminish ties. Several leaders emphasized the need to prevent their organization from being harmed by a board or staff member acting in inappropriate ways. Desire to maintain the organization's integrity and its legitimacy with other stakeholders compelled the leaders to remove stakeholders with low legitimacy from an internal authority position.

The seriousness and type of problem is significantly related to the response of diminishing ties. The more serious a problem, the more likely leaders are to resort to diminishing a stakeholder's involvement in an organization. For problems with little or no effect on their

organization's moral, financial, or artistic integrity, leaders are willing to tolerate some deviance by a stakeholder from organizational values, norms, or interests. If a problem involves a stakeholder's acting in a way that is inconsistent with an organization's values or norms, in other words a stakeholder legitimacy problem, leaders are more likely to end their involvement with the stakeholder.

When a problem involves an interest clash, leaders are less likely to cut or weaken ties. In these cases, a stakeholder's legitimacy is not in question so there is little danger that an organization's legitimacy will be contaminated by further interaction with the stakeholder. Therefore, leaders are more willing to compromise, try to persuade a stakeholder to change, or adapt their organization to improve congruence of interests. By changing or removing conflicting interests, leaders may increase the stakeholder's support for their organization. By cutting or weakening ties, this opportunity is likely to be lost.

Control of resources appears to provide some advantage to stakeholders interested in maintaining their influence in an organization. Leaders are more willing to try and change stakeholders who offer critical services or other resources. These stakeholders are often given second or third chances. For example, one director of a theater company described how he repeatedly explained the importance of coming to rehearsals on time to a highly valued actor with superb acting skills. Only after the actor's consistent failures to comply did the director fire him.

When age is excluded from the test of the model, we see that leaders of smaller organizations tend to cut or weaken ties to stakeholders in response to problems more often than leaders of larger organizations (see Appendix C, Table C.3). Rather than try to change a stakeholder to conform with their organization's interests, values, or norms, the leaders of smaller organizations tend to replace the stakeholder. Part of the reason may be that larger organizations have more resources to devote to improving a relationship with a stakeholder. In larger organizations, staff members may be available to work with stakeholders who are presenting problems for an organization. For example, a leader of one large organization arranged for staff members to work closely with volunteer groups who were not performing to desired standards.

Leaders of large organizations also may have the luxury of being more careful in appointing individuals to important positions and task groups, and therefore can avoid some of the serious performance problems that small organizations face. One director noted the importance of finding the right people to work in her organization. After describing difficult situations with volunteers not performing their roles adequately, she stated, "We're learning to be a bit more politically astute and appoint the right people for the right positions. And I don't think that's sneaky or shrewd at all; it's necessary for having something that runs more smoothly."

When Do Leaders Misrepresent or Conceal Information in Response to Problems with Stakeholders?

In the management of over 26 percent of the problem situations, directors reported some deceit with stakeholders. Leaders either withheld information or portrayed their organization inaccurately. In only 8 percent of the total cases were the deceits fairly complex and well-strategized. In the other 18 percent of the cases, the misrepresentation or concealment of information was not planned in advance and was not part of a larger web of deceit. In the majority of their dealings with stakeholders, leaders were open and honest. Several directors explicitly promoted the importance of honesty and trustworthiness in their dealings with stakeholders. A director from an arts center stated:

> We know that in order to keep that good status within the community we have to be careful to present quality and do everything with truth and honesty. So we're very cautious and careful about presenting artists or acts. All facts are truthful in the printed material, and we try hard not to offend anyone.

A theater director also noted the importance of avoiding deceit. He stated:

> Arts organizations get enough bad raps, and if you have a reputation, especially a good one, then you really have to preserve it. So when we do things, we go into it with that attitude. We are a good organization; we're not going to be shady, less than what its implied to be, less than professional, or anything like that—we won't get involved in it.

Table 3.8 shows the logistic regression results for the misrepresenting response. The model provides a borderline fit for the data. Both stakeholder importance and artistic quality issues significantly influence whether information is misrepresented or concealed.

As expected, leaders are less likely to use misrepresentations with more important stakeholders than with less important ones. On the rare occasions when leaders knowingly deceived important stakeholders, it was part of an extraordinary effort to improve an organization's financial stability. These misrepresentations tended to be more complex and difficult to maintain than the more simple, single-incident misrepresentations generally used for less important stakeholders. One director explained why organizational representatives had repeatedly lied about their organization's financial condition. He stated:

> In order to pay off IRS debts, in order to get loans, we had to be able to show an operating profit now. The only way to do that was by lying. [discussion of specific lies] Why? Because you had to be able to show a profit in order to be able to get loans. And as a result we got deeper and deeper entangled into all this stuff.

TABLE 3.8

**Test of Model of Misrepresenting or Concealing
Information Using Logistic Regression**

Variables	B	Standard Error	Wald Statistic	Significance
Stakeholder Resource Importance	- .442	.236	3.534	.06
Stakeholder Authority	.349	.246	2.012	.16
Organization Age	-1.117	1.109	1.015	.31
Organization Size	.655	.789	.689	.41
Mission Threat	-.814	.736	1.224	.27
Artistic Quality Issue	1.900	.830	5.218	.02
Problem Seriousness	.413	.353	1.369	.24
Problem Type			.539	.76
Organizational Legitimacy	.182	.447	.166	.68
Stakeholder Legitimacy	.139	.406	.118	.73
Constant	-.846	2.205	.147	.70

	Chi-Square	df	Significance
-2 Log Likelihood	81.390		n.s.
Model Chi-Square	14.605	9	.10
Model correctly classified	74.70 percent of cases		
N=83			

The analysis also shows that problems involving artistic issues are more likely to lead to misrepresenting responses than problems that do not involve artistic issues. Leaders often concealed information when they were trying to raise artistic standards. The leaders seemed to be balancing a desire to improve quality with a desire to maintain positive relationships with artists involved in their programs.

Refining the Stakeholder Management Model

The analyses for each response show that many of the hypotheses were supported. Combining the results of the analyses reveals a refined problem management model. The model remains rooted in resource dependence and institutional theory. Resource concerns and constraints are good predictors of responses to problems. Mission and reputation also play a role in predicting responses.

Figure 3.1 depicts the model supported by the analyses. The model is particularly well-developed for the opposing responses of adapting an organization and cutting or weakening ties to a stakeholder. It also provides some understanding of when organizations approach problems with a less clear choice to conform or not conform to a stakeholder's values, norms, or interests.

FIGURE 3.1
Significant Stakeholder Management Relationships*

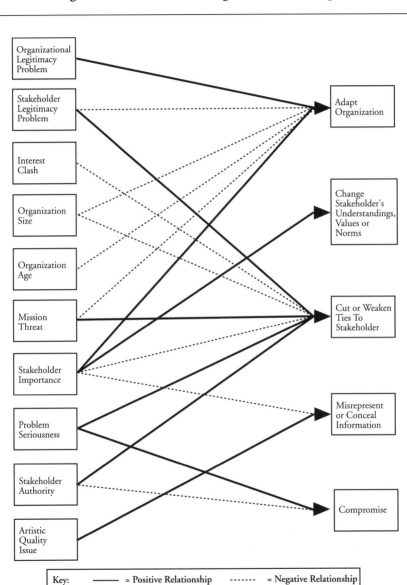

*All relationships shown are significant at the .10 level or better

Before discussing any management prescriptions and theoretical contributions that can be derived from the hypothesis tests, I offer supplementary analyses. These analyses are exploratory, but offer additional insights on the management of problems with stakeholders that help build a foundation for the study's implications. This chapter continues with an exploration of perceived satisfaction with the responses to problems. Chapter 4 explores the issues associated with different subgroups of stakeholders and underlying themes in the problems faced by nonprofit arts organizations.

Consequences of the Responses

Despite the best-laid plans, occasionally things do not work out as expected. Examining directors' perceptions of whether organizational responses to problems were successful enriches our description of the stakeholder- management process. This section explores directors' perceptions of the outcomes of their stakeholder-management practices.

No hypotheses were developed to explore the consequences of responses to problems. However, when time allowed, I encouraged directors to discuss their perceptions of what happened after a response was implemented. Two measures were created to look for patterns in the consequences. The first measure captures organizational leaders' satisfaction with the consequences of the responses. The second measure captures the leaders' perceptions of stakeholders' satisfaction. Table 3.9 shows the correlation of the two satisfaction measures with the use of responses.

The responses varied in their ability to satisfy leaders and stakeholders. Not surprisingly, when organizations adapted their purposes, activities, or outcomes to be more congruent with stakeholders, the directors thought that the stakeholders were satisfied. The directors did not report a clear link between organizational satisfaction and the use of adapting. In some instances an organization adapted only because of pressure from a stakeholder. In other cases an adaptation was supported by leaders for a variety of reasons, not all connected to a problem with a stakeholder. When leaders saw more general benefits from changing their organization, they tended to be more satisfied with the results.

When organizations cut or weakened a stakeholder's ties, the directors reported that stakeholders were not satisfied with the response. Leaders frequently attempted to conceal a stakeholder's loss of influence, or reframe the response to appear to be the outcome of a stakeholder's choice. In most cases, stakeholders were aware of organizational decisions to reduce their influence and sometimes fought to retain their ties. Stakeholders occasionally complained to other stakeholders about their mistreatment by an organization that had reduced their influence and tried to damage support for the organization. Even though cutting or weakening ties occasionally leads to unforeseen consequences, leaders are generally satisfied with their use of the response.

TABLE 3.9
Correlations Showing Satisfaction With Responses

N=78

Responses	Organizational Satisfaction	Stakeholder Satisfaction
Adapt Organization	.061 p=.587	.439 p=.000
Cut or Weaken Ties to Stakeholder	.180 p=.106	-.354 p=.001
Misrepresent or Conceal Information	-.081 p=.469	-.265 p=.019
Change Stakeholder's Understandings, Values or Norms	.047 p=.676	-.015 p=.897
Compromise	-.021 p=.914	-.015 p=.894

One director was frustrated by how her firing of a volunteer manager had originally been perceived as positive by other volunteers but became negative. Her story illustrates the often unpredictable political consequences of cutting or weakening a stakeholder's ties. The firing occurred at the urging of the volunteers supervised by the manager. Shortly after the firing, the success of the projects directed by the fired manager became apparent to the volunteers. The manager began contacting the volunteers engaging their support for her reappointment and indictment of the organization for the firing. The volunteers called for the manager's rehiring, refusing to acknowledge their role in the initial firing decision.

Misrepresenting or concealing information does not appear to be a generally successful strategy for maintaining stakeholder satisfaction. However, use of deceits had multiple purposes. In addition to being used to try to gain or maintain stakeholder satisfaction in a problem situation, deceits also were used to prevent future problems from occurring. For example, a board member who was given incorrect information about a meeting time may have been unhappy that she missed the meeting, but the deceit may have been effective in preventing her from disrupting the meeting. According to directors, low stakeholder satisfaction resulting from a misrepresentation may have been the lesser of two evils.

Compromising and trying to change a stakeholder had less clear effects on organizational and stakeholder satisfaction. These responses were not always completely successful in resolving or reducing the negative effects of problems. They also may have drained an organization of resources that leaders wished could have been used for other activities. Some directors felt that trying to change a stakeholder's understanding was a general cost of doing business.

In order to carry out their missions, leaders had to explain their organization's needs and expectations to stakeholders. The leaders were neither pleased nor displeased with their performance of this interpretation role.

Summary

This chapter revealed patterns of stakeholder management used in nonprofit arts organizations. We see that leaders pursue multiple options and objectives in managing problems with stakeholders. Leaders are motivated by desires to protect their missions, preserve or regain legitimacy, and safeguard the trust and support of their community. To accomplish these objectives, they use a variety of strategies, including adapting their organization, trying to change a stakeholder, cutting or weakening a stakeholder's ties to their organization, misrepresenting or concealing information provided to a stakeholder, and compromising with a stakeholder.

Choices of strategies are linked to leaders' interpretations of the nature and significance of problems and to their predictions of the consequences of different responses. As expected, interest clashes, stakeholder legitimacy and organizational legitimacy problems raise different issues for leaders and result in different patterns of responses. Resource dependencies play a part in determining responses, as do fears about misuse of authority by stakeholders. Organization age and size also contribute to the constraints experienced by leaders in choosing and crafting their responses to stakeholders.

Use of the responses may or may not lead to organizational and stakeholder satisfaction. While cutting or weakening ties generally leads to low stakeholder satisfaction and adapting leads to high stakeholder satisfaction, the consequences of the other responses on stakeholder satisfaction are less clear. Even if we found clear cause-effect links between satisfaction and use of all the responses, our stakeholder management model would be incomplete. The multiple objectives and other influences affecting responses, and the prevalent use of combined responses, suggests a complex arrangement of stakeholder management challenges addressed by leaders.

4

EXPLORING CHALLENGES ASSOCIATED WITH STAKEHOLDER GROUPS

Chapter 3 examined how stakeholders' control of resources and decision authority influences responses to problems. This chapter expands this treatment of stakeholder characteristics by looking for patterns in problem occurrence and management related to particular stakeholder groups. Different groups of stakeholders may have unique interests in an organization and operate with distinct values and norms. Their expectations and actions may raise specific management challenges and dilemmas for organizational leaders.

Stakeholder Mapping

Stakeholder analysis or "mapping" is a skill that has been commonly taught in professional management programs since its promotion by Freeman (1984) in his work on strategic management. Consultants use stakeholder maps to help leaders manage organizational transformations and conduct strategic planning. Examination of the network of stakeholders connected within and outside an organization helps in the identification of possible outcomes of organizational actions, available resources, and constraints. It also aids ethical and moral deliberations (Frost, 1995) and the development of social-responsibility initiatives in organizations (Swanson, 1995). Stakeholder assessment even has a place in policy design and implementation (Altman & Petkus, Jr., 1994; Bryson, 1992). Leaders may make better policy choices if they understand how and why stakeholder groups may affect and be affected by policies.

To create a map, all the stakeholder groups linked to an organization are identified. Then, the stakeholders' goals, expectations, criteria for evaluating an organization, mechanisms for influencing the organization, and importance to the organization are determined. During my interviews with directors, I asked for a list of all their stakeholders. I gave the direc-

tors the traditional definition of a stakeholder as a group or individual who influences or is influenced by an organization. The directors' lists are combined in Figure 4.1 to present the beginnings of a generic stakeholder map for a nonprofit arts organization. Given additional time and prompting, the directors may have added more stakeholder categories to the map. The figure presents the directors' unprepared responses to my request and therefore captures the most obvious stakeholder groups from a director's perspective. For a complete stakeholder assessment, each stakeholder group would be examined to understand the stakeholders' unique contributions to an organization, perspective on the organization, expectations for the organization, interests in the organization, and means of influence over the organization.

Not all the stakeholders shown in the figure are directly involved in the problems reported by directors. In discussing a problem with one stakeholder, the directors frequently mentioned other stakeholders indirectly involved in the problem. The group to which a stakeholder belongs and its links with other stakeholder groups appear to play a part in the type of problem the stakeholder presents and how that problem is managed. Leaders of organizations may create mini-maps of particularly relevant stakeholders when facing a problem with a single stakeholder. For example, one director worried about potential problems with artists and patrons resulting from the state arts council's request that his organization return a grant because of the council's funding difficulties. The return of the grant was likely to result in the cancellation of programs, forcing the organization to break contracts with artists and change a subscription series after series tickets were sold.

Table 4.1 shows the breakdown of problems in the study by the stakeholder involved and the artistic domain of the organization. Some of these stakeholder groups could be further subdivided for more in-depth analysis. For example, contributors could be divided into foundation, corporate, and individual contributors. However, the small sample size limits the analyses that can be made with this subdivision.

The chi-square statistics reported in Table 4.1 show that directors of some types of organizations reported significantly more problems with particular stakeholder groups than directors of other types. Directors of arts centers discussed more problems with board members; symphony directors presented more problems with paid employees; and theater directors reported fewer problems with other arts organizations. Directors of arts councils, theaters, symphonies, and arts centers did not significantly differ in their reports of problems with patrons, volunteers, contributors, media, business contacts, artists outside their employ, and miscellaneous others.

FIGURE 4.1

Stakeholder Map for Nonprofit Arts Organization

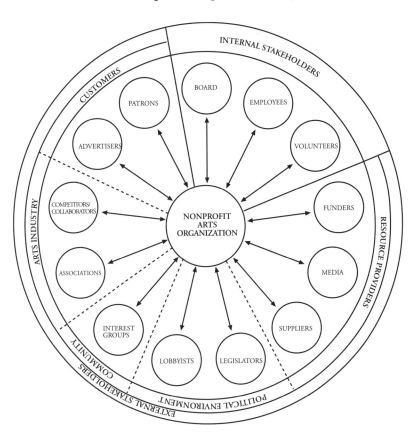

Definitions of Categories:

Patrons: audience, clubs, study groups, commissioners of works, contractors of performances
Funders: members, individual donors, corporate donors, foundations, government, united funds
Board: president, organizational affiliations of appointed seats, committees
Employees: staff, amateur and professional artists
Volunteers: volunteer associations, individual volunteers, volunteer chairpersons
Associations: professional and technical associations, unions, industry alliances
Competitors/collaborators: nonprofit and city cultural or recreation agencies
Interest groups: chambers of commerce, developers, tourism bureaus, businesses, public
Media: television, radio, print
Advertisers: businesses with ads in organization's programs or newsletter, event sponsors
Legislators: county commissioners, senators, representatives, city councils
Lobbyists: arts advocacy organizations
Suppliers: publishing houses, playwrights, performance spaces, exhibit sites

TABLE 4.1

**Breakdown of Number of Problems by Type
of Organization and Stakeholder**

Stakeholder	Arts Council	Theater	Symphony	Arts Center	Total	% of Total	Chi-Square Likelihood Statistic
			Type of Organization				
Board member	1	2	1	7	11	13.3%	6.19, p=.10
Patron	4	1	0	3	8	9.6%	3.86, p=.28
Volunteer	8	3	1	2	14	16.9%	6.08, p=.11
Paid employee	1	4	8	4	17	20.5%	16.78, p=.001
Contributor	2	3	0	2	7	8.4%	3.81, p=.28
Arts Organization	4	0	3	5	12	14.5%	6.34, p=.10
Media	1	1	0	1	3	3.6%	1.17, p=.76
Business Contact	2	0	0	1	3	3.6%	3.16, p=.37
Outside Artists	1	2	0	0	3	3.6%	5.02, p=.17
Other	2	1	0	2	5	6.0%	1.82, p=.61
Total	26	17	13	27	83	100%	

The demands and working conditions placed on boards of arts centers may have contributed to the greater number of problems involving boards discussed by center directors. Offering both visual and performing arts, the arts centers have more diverse missions than most of the other types of organizations in the study. Only the arts councils share a concern with presenting works in a variety of artistic disciplines. Councils have the added responsibility of grantmaking. The programming breadth available in arts centers presented opportunities for board members to argue for favorite programs and form coalitions for and against staff members working in different program areas. Stakeholder legitimacy problems and interest clashes resulted when differences of opinions led to inappropriate actions or interpersonal conflicts.

On average, the arts centers operate largely from earned income and individual donations. Many board members of the centers are heavily involved in running special programming and fundraising events. In contrast to the theaters and symphonies, board members of arts centers are more involved in day-to-day operations. Greater involvement brings greater opportunity for board members to create problems for their organizations.

The proportionally greater number of problems with paid employees faced by symphony orchestras can be explained in two ways. First, symphonies have more permanent paid staff, artistic and administrative, than the other types of organizations. Based simply on number of employees, they have greater potential for problems with personnel. In contrast, arts councils have the smallest staffs and, not surprisingly, only one problem with a staff member was reported by a leader of an arts council. Many of the symphonies' problems with staff are related to their transitional states at the time of the interviews. Almost all the sympho-

nies were professionalizing their artistic staff or facing budget crises. In the quest to improve quality or maintain financial viability, new expectations were being placed on artists. In some cases, leaders were renegotiating commitments to the staff as the organizations changed orientations. Tensions resulting from these changes led to many of the problems concerning employees that symphony directors discussed.

Theaters differ significantly from the other types of organizations in their leaders' reports of problems with other arts organizations. No theater director discussed a problem involving another arts organization. Among the organizations in the study, the theaters collaborate the least with other arts organizations and appear to face fewer competitive pressures than symphonies and arts centers. The theaters generally operate without the assistance or involvement of other arts organizations. Many of the theaters in the study have distinctive marketing niches and an ample labor supply. Few of the theater directors expressed concerns about overlapping events with other organizations. Unlike some of the symphonies, the theaters do not appear to need to compete for artists. The greatest struggle for many of the theater directors is finding adequate funds to support programming. Three of the four theaters were facing severe financial problems during the study, primarily because of their heavy reliance on ticket sales. Still, none of the theater leaders felt that their current financial stresses were influenced by the competitive activities of other arts organizations in their community.

Issues and Responses for Key Stakeholder Groups

Identifying the issues and behavior patterns recurring in relationships with particular stakeholder groups allows additional insights to be drawn from the study. Board members, patrons, volunteers, paid employees, contributors, and other arts organizations were the most frequently reported by the directors to be involved in problems. The following sections explore special features of problem management with these stakeholder groups.

Problems with Board Members

Board members are the stakeholders in 13 percent of the problems studied (11 cases). The most common response to a problem with a board member was to prevent further problematic activities by cutting or weakening ties. In 7 of the 11 cases involving problems with board members, the board member's influence was reduced. Adapting was never used to manage a problem with board members. Board members were rarely given an opportunity to defend their departure from the organizational values, norms, and interests specified by powerful organizational leaders.

Typically, books on board development attempt to prevent problems with individual board members by promoting use of board orientations, mission and vision planning sessions, board appraisals, and other management techniques. Approximately a third of the directors told me that their organization had formal board training activities. Whether or not a board went through developmental activities with a consultant, or had comprehensive board orientation sessions or manuals, made no significant difference in whether directors reported problems with their board members. Also, older organizations, which presumably have had greater opportunities and experience in developing board skills, are just as likely to face a problem with a board member as are younger organizations.

Some of the problems resulted from board members rejecting or not fully understanding their responsibilities as stewards of their organization. As Jeavons (1994) explains, a steward is defined by "his or her commitment and allegiance to someone or something greater. His or her appointed task is to attend to another's interests." When board members pursue their own interests through their position of authority, they are not acting as organizational stewards. They also are not acting as true stewards when they pursue short-term financial ends without remaining true to their organization's mission. This study found more than one example of both these types of activities by board members.

Board members may have good intentions when they use their positions in ways that others view as inappropriate. Given the financial strains and strong fundraising emphasis in some organizations in the study, it is no wonder that individual board members sometimes moved beyond appropriate bounds to bring money into their organization. Balancing multiple objectives is a difficult and necessarily thoughtful task.

In my study, the arts centers had the most diverse missions and reported proportionally more problems with their board members than the organizations in other artistic domains. The problems that the arts center directors reported tended to involve board members disagreeing about what their organization should be doing, or acting in ways that dilute or contradict each others' efforts. When board members devote inadequate time and effort to their stewardship responsibilities, misunderstanding of organizational priorities is a potential outcome, particularly when priorities are unclear as they often are in arts organizations offering multiple art forms.

There is a lack of a consensus in this society concerning trustees' roles and responsibilities (Hall, 1992). Board members may face conflicting pressures and expectations leaving them with unclear guidance regarding appropriate attitudes and actions. Diverse backgrounds of board members may result in conflicting values and norms manifested in political battles with other board members and staff. Board members may disagree about their organization's interests and desired identity. They also may disagree about what practices may damage their organization's reputation. Membership of a board member in the dominant coalition usually determines whether their values and norms are considered mainstream and accepted as guides for decisions.

Discouraging diversity is no solution. Although similarity may ensure that board members rarely disagree and create "problems" for their organizations, it reduces stimuli for engaging in discussions about mission and vision. Boards encouraging the verbal expression of controversial or minority values and norms may find benefit in any conflicts that follow. As Smith (1995) argues, board members need to consider the "moral quality" of their organization's activities. In doing so, they need to discuss what services they should be offering, whether those services are worth providing, how well they are providing the services, and who has access to the services. Multiple perspectives can help strengthen the board's capability for the reasoning and visioning that this discussion requires. Explicit board agreement about organizational values, norms, and priorities may deter individual board members from acting in ways that leaders might interpret as inappropriate.

Problems with Patrons

Difficulties with patrons, defined as direct users of services, comprised 10 percent of the problems studied. The leaders revealed a strong customer orientation in their responses to patrons. Patrons were significantly more likely to be satisfied with organizational responses than other types of stakeholders (likelihood ratio chi-square=10.07, p=.04). Leaders adapted their organization in response to half the problems with patrons. Leaders were significantly less likely to try to change patrons' values, understandings, and norms than to try to change other types of stakeholders (likelihood ratio=4.87, p=.03). Leaders used this strategy for 25 percent of the problems involving patrons. For other types of stakeholders, leaders used this strategy in 65 percent of the problem cases.

Patrons implicitly raised a variety of issues that have long been discussed as dilemmas for arts organizations: elitism versus populism, revenue optimization versus service, artistic freedom versus social appropriateness, and community participation versus professionalism (see DiMaggio, 1986, for discussions of some of these issues.) Only directors of younger organizations (organizations less than 25 years of age) reported that patrons raised these issues. The older organizations appear to have established whom they wish to serve, how, and with what economic and normative constraints. Several directors of younger organizations faced conflicting pressures from their patrons, usually involving disagreements about whose interests their organizations should be serving and how best to serve those interests.

As an organization ages, perhaps its contribution to its community gets scripted. In other words, over time organizations and patrons may develop and perform scripts containing behavioral sequences deemed appropriate for specific situations (Gioia & Poole, 1984; Abelson, 1976). Patrons' interaction with an organization through organizational activities may become taken for granted and routinized. Younger organizations may operate in an environment with less awareness and consensus concerning what the organization is and what its programs should be. Patrons of younger organizations may have fewer scripts

to guide their interactions with the organization, and have greater leeway to devise their own expectations for the organization. When an organization does not meet these expectations, patrons may complain and place demands on the organization. Leaders of younger organizations may be unable to enact scripts in responding to patrons, making problems with the patrons more evident and troublesome.

This may explain why only directors of younger organizations reported problems with patrons. Directors of younger organizations discussed patron-inspired debates by board and staff about whether to serve mass market or more elite tastes, and whether or not to lose money on programs. They also reported debates on how to handle controversial art and how much quality standards should be sacrificed to allow more community involvement in the delivery of programs. Directors of younger organizations also shared more mundane problems related to the delivery of programs, such as whether or not to accommodate an individual patron with special dietary preferences. Sometimes leaders needed to encounter several problems related to the same issue before they became comfortable and consistent with their answers to the issue. Under stress, leaders sometimes acted quickly to satisfy a patron despite the response's inconsistency with previous decisions or actions related to an issue. Over time, unique problems with patrons may become less frequent and responses more scripted.

A perhaps simpler explanation for why directors of older organizations did not report any problems with patrons is that organizations gain knowledge about their markets over time. This knowledge may allow them to fine-tune their programs to satisfy patrons' interests. Understanding their market niche and using "tried and true" programs may keep older organizations in congruence with their patrons. This explanation has some holes. For one, many older organizations in the study were well known for their innovativeness and willingness to offer programs that could raise controversies. For example, one director of a long-established theater was disappointed that a show involving actors performing in the nude did not seem to disturb patrons. This director was most comfortable when he was stretching the limits of his patrons' tolerance and artistic sensibilities. Second, most of the organizations, young and old, were trying to expand their audience bases. Older organizations did not have more knowledge about these new markets' interests, values, and norms than their younger counterparts.

Problems with Volunteers

Volunteers were involved in 17 percent of the problems explored in the study. (Volunteers involved in administrative functions were involved in 7 percent of the total number of problems, and volunteers offering artistic services were involved in 10 percent.) The smaller organizations in the study reported more problems with volunteers than the larger organizations (likelihood ratio chi-square=6.95, df=2, p=.03). The directors reporting volunteer problems rarely had a formal volunteer coordinator on staff. They relied more on volunteers'

self-management than on direct supervision. The volunteers were most likely to be involved in stakeholder legitimacy problems and least likely to be involved in interest clashes (likelihood ratio chi-square=4.84, df=2, p=.09).

Most of the problems resulted from organizational failure to structure volunteer jobs and properly select, train, motivate, and supervise volunteers. The volunteers did not understand what they should be doing and why, and consequently created problems through violation of the organization's expectations, values, and norms. Given the latitude to define their own tasks, they sometimes went beyond desired boundaries, acting in ways that were against organizational policies and mission. In other cases, they were inadequately prepared for assigned tasks and failed to perform up to leaders' expectations. Feedback on their performance was often minimal, compounding the problems because volunteers assumed they were acting effectively and appropriately. Many of the problems involving volunteers escalated from minor violations. If the directors had addressed the more trivial problems with volunteers, providing guidance and justifications, the larger problems may have been avoided.

Volunteers also presented a few organizational legitimacy problems, questioning the appropriateness of their organization's mission, structures, and activities. If they had better understood their organization before becoming a volunteer, they may have chosen not to become involved. However, by raising legitimacy concerns, volunteers sometimes sparked useful debate among organizational leaders, leading to thoughtful improvements in organizational purposes, structures, and practices.

Problems with Paid Employees

Paid staff were involved in 20 percent of the problems discussed by directors. Most of these problems involved artistic staff. Staff were involved in significantly more legitimacy problems than interest clashes (likelihood ratio=8.46, df=3, p=.04). The sources of problems almost exclusively involved violations of values and norms. Common problems reported by directors of arts centers, theaters, and arts councils included staff not performing up to standards, fighting over organizational priorities or distribution of resources, and not treating each other as respectfully as their director desired.

The types of problems experienced with employees are common across all types of organizations, nonprofit and other. However, some directors claimed that the temperamental nature of artists contributed to the presence of these problems in their organizations. Several directors expressed the same stereotype of artists as egotistical, demanding, and driven. They most frequently applied this stereotype to artistic directors. Most of the directors who had to share authority with an artistic director complained about tensions between artistic and administrative goals that sometimes placed the directors in opposing camps. When executive and artistic directors were in conflict, boards were forced into a facilitator or final authority role.

Problems with Contributors

Most of the problems with contributors occurred because the arts organizations did not honor their commitments to the contributors. They either did not give proper credit to the donors or did not use gifts as donors expected. Directors of younger organizations primarily reported these problems. The directors considered these problems to be serious but sometimes they were unable or unwilling to remedy them because of resource or other constraints. For example, one contributor was upset because his business was not acknowledged as a sponsor of an event. The director believed he could not force the media or co-organizers of the event to acknowledge the sponsor and was left with little to do except offer apologies to the sponsor.

One clear lesson to be drawn from the directors' stories about problems with contributors is that leaders need to consider, in advance, the obligations associated with accepting gifts. Some problems occurred because leaders were not fully aware of the constraints that prevented them from fulfilling contributors' expectations. Although the directors generally had the intention and desire to honor donors' wishes, occasionally they could not do so. By more accurately portraying their constraints to contributors, they may have failed to attract some gifts their organization otherwise received. However, they may have avoided the contributors' displeasure when commitments were not honored.

Problems with Other Arts Organizations

Most of the problems with other arts organizations reported by directors involved interest clashes. More than 14 percent of the problems in the sample involved problems with another arts organization because of competition for audience members or failure to collaborate successfully on a joint event. Leaders were significantly more likely to compromise to resolve problems with other arts organizations than to compromise with other types of stakeholders (likelihood ratio=4.66, p=.03).

All the directors identified their organization as part of a larger network of arts providers. Yet, very few of the organizations in the study engaged in formal collaborations with other arts organizations. Those that did were larger and had partners that offered resources unavailable through independent effort. Mostly, cooperative activities were limited to reciprocity arrangements. When it was consistent with self-interests and norms of etiquette, organizations exchanged information, coordinated program dates, promoted each others' activities, and avoided delivering similar programs. Leaders of arts organizations that did not extend these professional courtesies were perceived by the directors to be unusual and looked upon with frustration and dismay.

Adopting a network perspective improved leaders' strategic planning. When "competitors" entered their service area, leaders often reevaluated their programming and fund development practices to see if they should make any adjustments to protect their organizations.

When they thought competition limited their organization's ability to deliver its mission, leaders generally sought compromises.

The leaders appear to focus more on responding to threats than opportunities presented by other arts organizations. Perhaps this apparent imbalance is a product of my study's focus. If I had not asked the directors to discuss problematic relationships with stakeholders, they may have shared more positive experiences with other arts organizations. Still, my review of promotional materials and grant proposals revealed few collaborative ventures. Freedman (1986, p. 207) may have been correct when he said:

> It is difficult to overestimate the intensity with which many performing arts organizations view themselves to be in competition with other companies for audiences, and more fiercely for contributed income. This competition has a visceral feel to it and can be traced in large measure to survival instincts and the constant, gnawing sense of not having enough money to continue operating in a viable manner.

Organizational leaders probably have no doubt that their organizations gain advantages by maintaining successful relationships with other arts organizations in their communities. Through skilled cooperative and collaborative efforts, leaders may leverage scarce resources and expand their financial returns and audience bases. Organizations that collaborate also may enhance the quality of their programs through shared expertise and creativity. Still, the directors I interviewed who discussed problems with other arts organizations expressed frustration with the difficulty of this process. A director explained that efforts to coordinate activities require careful attention, willingness to compromise and be flexible, and agreement on shared interests to be successful. Several directors felt that compatibility of personality and management styles influenced their ability to work well with other arts organizations. Stressful and demanding conditions due to stretched resources, inadequate expertise or skills, or deadline pressures made it especially difficult for directors to keep the interests of other arts organizations in mind.

Summary

This chapter reviewed the major stakeholder groups involved with nonprofit arts organizations. Special attention was given to the problem management practices and issues related to boards of directors, patrons, volunteers, paid employees, contributors, and arts organizations. This analysis of stakeholder groups, combined with the analyses of predictors of responses and satisfaction examined in the previous chapter, build a foundation for advancing a framework for stakeholder management in the nonprofit sector. This framework is explored further in the next chapter, along with a discussion of implications for theory and practice.

5

ARTFUL LEADERSHIP

This chapter presents aspects and implications of stakeholder management that were not fully elaborated in the previous chapters' analyses of predictors of responses and key stakeholder groups. First, I discuss the nature of the process of managing problems. Then, I explore goals and responsibilities guiding the process. Next, I explain how leaders use a network perspective in their problem management. The chapter ends with a brief discussion of the applicability of the frameworks and findings to other settings.

The Deliberate and Emergent Nature of Problem Management

I have described the process of problem management as involving scanning for problems in relationships with stakeholders, interpreting the problems, evaluating options, and responding to the problems. Feedback from this process influences future problem-management cycles. Leaders may approach this process with more or less deliberateness and consistency. Common interests, constraints, preferences, and understandings, along with other internal and external pressures, may lead to patterns in problem responses, no matter how conscious and planned the actual decision-making process.

Primarily, I have treated stakeholder management as a boundedly rational process (Simon, 1960) in which leaders or their representatives consider a variety of factors in choosing responses. Leaders do not know all there is to know about a problem situation, but given information limitations, they choose a strategy that they think will lead to satisfactory consequences. For example, when leaders thought it was in their organization's interests, they compromised. When they wanted to gain legitimacy with a stakeholder, they often adapted their organization to be more congruent with the stakeholder.

Not all responses to problems with stakeholders are the outcomes of a deliberate decision-making process. Some responses to stakeholders may be routinized or scripted. Over time, positive consequences of the use of a response may reinforce the response's perceived value and encourage its automatic adoption when new problems arise. Leaders may be unaware of

this patterned behavior and their consistent assumptions. For example, leaders may assume that "the customer is always right" and consistently adjust their organization in response to complaints by patrons. The resulting positive feedback from the complainers (or negative feedback if no apparent change is made in response to the complaint) may reinforce the leaders' sense that adaptation was appropriate and encourage a customer-satisfaction script. As another example, leaders may have a long history of contract battles with unions. Because of this history, they may consistently approach unions as adversaries and fail to see collaborative potential.

Some response options may be prescribed. For example, agreements with a union may prevent leaders from cutting ties to an employee if predetermined conditions are not met. Bylaws may state the requirements and procedures for electing board members and revoking their board positions. Directors may be required by law to reveal information to external stakeholders.

Leaders may plan responses that are not implemented as desired, or that do not lead to expected outcomes. Incorrect assumptions about causes and effects, unforeseen circumstances, chance, and other constraints may undermine plans. For example, a board may dictate that volunteers be treated a certain way, but it is up to the staff to see that the plans are implemented. One director in the study discussed how a board mandated that volunteers submit budgets for approval to prevent continued inappropriate use of funds by the volunteers. Without the knowledge of the board, some volunteers used their social connections with staff members to bypass this requirement.

Just as consistent themes often can be identified in an artist's products, it is often possible to identify patterns in organizational leaders' problem management. Mintzberg's (1987) illustration of strategy as a "craft" helps to elaborate this point. Mintzberg explains that potters do not always know exactly what their efforts will bring. A pot's form may gradually emerge to be accepted or reformed with a firmer hand. Potters find value in experimentation, allowing the clay or their hands to dictate a pot's shape. Still, their hands are guided by what they know has been successful in the past and by the limit of their material and available technology. When potters want conformity, they may plan a shape before they touch the clay and control as many contingencies as possible to see that the shape is realized. Leaders may approach stakeholder management in the same fashion, varying in their deliberateness and the consistency of their outcomes.

Statements of Values and Goals for Stakeholder Relationships

Much has been written about how to improve decision-making processes. Brainstorming techniques, procedures for avoiding groupthink (Janis, 1982), ranking of an option's capability to satisfy multiple goals, and other decision tools are available to help solve specific problems. It is

unreasonable to believe that leaders will spend the time and effort to use these tools every time they face a problem with a stakeholder. Some problems receive little if any attention if the benefits of considering the problem do not outweigh perceived costs. Leaders also may not have the time or resources to employ the tools.

Leaders can find value in discussing stakeholder management more generally. Explicit discussion of goals for their organization, and how these goals may be reflected in the quality of their relationships with key stakeholders, can lead to standard criteria for evaluating response options. A formal mission statement serves as an orienting and accountability device for programs. Similarly, a statement of values and goals for relationships with stakeholders can help ensure that responses to stakeholders are cohesive and serve the organization's interests. For example, to maintain some level of organizational independence and financial stability, leaders may set a maximum percentage of total income that one stakeholder can contribute to their organization's income. The board and staff's acceptance of this goal reduces the possibility that such a contribution would be pursued and that conflicts would result if the contribution were offered.

Analysis of History of Problems with Stakeholders and Relevant Trends

Grouping past problems with stakeholders according to shared themes may be helpful in building awareness about systematic pressures and organizational weaknesses. Two recurring problems experienced by more than one organization in the study involved poor performance of volunteers and inability to honor promises to contributors. By seeing how often the same types of problems occurred, leaders have the beginnings of a priority list for designing new structures and policies to avoid problems in the future. For example, leaders of organizations who have a disproportionate number of performance problems with volunteers may decide to hire a volunteer coordinator or prepare an orientation manual for volunteers. If leaders do not regularly review their history of stakeholder problems, they may fail to see the patterns and the need for changes.

By searching for patterns in experiences with stakeholders, leaders may uncover the assumptions, values, and norms guiding organizational and stakeholder actions. Assumptions can be challenged and changed if appropriate. Understanding the values and norms that are consistently in conflict can help in the prediction of future problems with stakeholders. This understanding can guide the resolution of problems if leaders can find ways to improve the congruence of the values and norms without compromising their organizations' or stakeholders' integrity.

If congruence is not possible, leaders may proactively search for stakeholders who hold more compatible values and norms. By switching from a resource provider who holds incongruent values and norms to one more compatible, leaders may remove a source of po-

tential problems. Of course, it is not always possible for leaders to dictate who will and will not be their stakeholders. For example, government regulatory agencies cannot be removed from a stakeholder map. However, leaders can reduce regulators' power to influence their organization by adding other external watchdogs to their stakeholder map. Leaders may get endorsements of their practices from an association within their industry that shares their values and norms. Accreditations or certifications may help bolster an organization's legitimacy with other stakeholders and make it less vulnerable to scrutiny or criticism.

No organization has complete control over its environment. Recognizing the diverse pressures affecting relationships with stakeholders may help leaders see what forces they can and cannot control. Monitoring changes in these pressures may help leaders appropriately adjust the dynamics of their relationships with stakeholders. For example, recent well-publicized scandals involving nonprofit organizations appear to have encouraged greater accountability demands from external stakeholders. Some leaders in this study addressed changes in the public's cynicism by proactively making potential and current donors more aware of their organization's accounting practices and financial standing. Expectations of economic pressures from cutbacks in state arts funding prompted many leaders to seek more foundation and corporate support to alter their resource dependencies. Without looking ahead to identify future pressures, these leaders may not have been as prepared to face external demands for accountability and internal needs for new funding sources.

Goals and Responsibilities Guiding Problem Management

This study revealed that arts leaders operate with some common goals. The leaders share a strong focus on preserving their mission. Most are greatly concerned with resource flows and adjust their relationships with stakeholders to help maintain their financial viability. Many leaders also have a missionary zeal in expanding their audience, improving public awareness, and maintaining a good reputation. Leaders not only act to achieve these goals, they simultaneously try to honor their responsibilities to their stakeholders. Leaders' varying commitments to satisfying stakeholders' interests, legal rights, and moral rights led to many of their problem-management challenges.

Mission Delivery over Resource Needs

Maintaining mission integrity is the premier motivation for the nonprofit arts leaders studied. Given a choice to maintain important resource flows from a specific stakeholder or preserve their mission, economic considerations were usually secondary. This conclusion may reassure Adams and Perlmutter (1995) who worry that nonprofits may be becoming more like businesses with greater emphasis on resource mobilization than mission. The

leaders in my study clearly have a mission-centered focus. As one director put it, "If you judge the success of an event by the dollars that come in, we feel that's looking at it from the wrong way."

Those worried that the financial stability and survival of arts organizations may be in danger because of a strict mission focus also may be reassured. Despite Brinkerhoff's (1994) admonition that nonprofits must not sacrifice the goal of "doing well" to "do good," most of the leaders studied are able to remain focused on their mission while pursuing needed resources. When mission is not threatened, the leaders actively seek to maintain or increase resource flows from problematic stakeholders. They are more willing to invest their organization's efforts to satisfy a stakeholder when the stakeholder controls important resources than when the stakeholder's resources are less critical to their organization.

Still, there is some cause for concern. Under conditions of continuous financial stress and uncertainty, some leaders operate with faith that needed resources will emerge. Instead of considering adapting to reduce financial strains, they endure the strains with the expectation that in time their financial woes will somehow end. Their confidence in their mission's value to their community and an eventual increase in support lead them to a strategy of trying to maintain the status quo with stakeholders. Given this optimism, they did little to establish new sources of support and were reluctant to end relationships with stakeholders that were draining resources from their organization. A few of the leaders also felt justified in deceiving stakeholders when their honesty might result in reduced financial support and, consequently, more difficulty in delivering their missions.

Strong commitment to a mission is generally desirable. However, if it creates stagnation and resistance to innovation in response to environmental changes, it may be dangerous for the organization's long-term viability and service to patrons. Patrons' interests may shift over time as do organizational capabilities and constraints. Willingness to adjust or add to a mission to capture new patron demands and funding interests may save an organization from death. Only if an organization survives can it continue to serve its traditional patrons without engaging in deceit.

Missionary Work: Improving Public Awareness and Perceptions of Legitimacy

My interviews revealed that many directors and board members were not satisfied with the level of public awareness and support of their organizations. Their desire to change these impressions influenced their interactions with stakeholders. Although the directors rarely used the word "legitimacy," they stressed the importance of maintaining their organization's image, reputation, and prestige, and keeping the public's or other stakeholders' trust, respect, approval, and goodwill. When stakeholders disapproved of their organization's activities or outcomes, leaders often adapted their organizations. When they discovered that a stakeholder had acted illegitimately, they generally cut or weakened their ties to the stakeholder, particularly when the stakeholder had a position of authority in their organization.

Many leaders talked about the education, or in one director's words, the "missionary work," needed to raise community awareness, acceptance, and involvement. Younger and smaller organizations in particular faced this challenge. So did those that did not have a facility and that had a history as a "women's organization." Leaders of two such organizations hoped that moving into a new facility, and drawing in more male patrons and service providers, would bring greater respect to their organizations. One board member explained why legitimacy was a problem for her organization:

> . . .mostly because it's been a women's organization, and I feel a number of people discount that: 'Oh yes, the ladies are doing this or that.' It isn't given enough credit because it's women doing it. As more men are brought into the organization and become part of it, then the community will give it more credit.

Even some leaders of larger, more established organizations felt that they weren't reaching everyone who could benefit from their programs. One leader of an arts museum stated, "I think there is this perception on the part of people that arts organizations like ours are always struggling, which is true, never get enough people to come in, which is true, and are always dismal failures, which is not true." Convincing the public that their organization is going to survive, and that it offers something of value to their community, are two campaigns that most leaders waged at least once during their organization's history.

Legitimacy judgements are applied to specific acts, not just to organizational entities (Rawls, 1971). The legitimacy of particular purposes, activities, or outcomes involved in problems with stakeholders predicted responses to the problems. Directors never discussed their view of a stakeholder's overall legitimacy. The directors' focus was on the legitimacy of something the stakeholder had done or was planning to do. They reacted to the legitimacy of the act. Additional research focusing on the effects of the legitimacy of actions, not organizations, may prove fruitful. An organization's and stakeholder's consistent performance of legitimate acts may have as much to do with their survival and ability to attract resources as their overall legitimacy.

One of the commonly stated functions of board members is to enhance their organization's public image. Board members' service as symbols of their organization's reputation and integrity makes any violation of values and norms by a board member particularly damaging to an organization. Leaders in this study consistently met these violations with swift action to remove or isolate the board member who had acted inappropriately. This response may have prevented the situations from escalating to full-blown crises.

In his manual for board members, O'Connell (1985) argues that the most essential quality of a leader is the ability to determine what is right. Boards members who can decide what is right, and act based on that decision, best protect their organization's public image. Selecting board members with demonstrated integrity can help ensure that the right decisions

are made. Encouraging boards to discuss their organization's image and how best it can be promoted and protected also can help.

Satisfying Stakeholders' Interests and Claims

The success of leaders in delivering their mission and attracting needed resources may be related to the configuration of "stakes" in their organization. A stake is an interest or a claim (Carroll, 1996) held by a stakeholder. According to Carroll, a stakeholder has an interest in an organization when the organization's decisions can affect the stakeholder. A stakeholder has a claim in an organization when the stakeholder has a legal or moral right to be treated a certain way by the organization.

There were only a few cases in the study in which legal rights were highly relevant. In one case, an organization's neighbors successfully sued to prevent the organization from holding noisy outdoor performances. The leaders attempted to persuade the neighbors to abdicate their legal rights and allow the organization to maintain its outdoor programs. Another example involves the "decency standard" of the National Endowment for the Arts. The Endowment required arts organizations receiving funds to sign a statement that they would not present "obscenity." Many leaders of arts organizations refused to accept Endowment grants because the attached legal requirement might compromise their missions, and the artists' right to freedom of speech. But the leader of one theater in the study with a grant intentionally presented plays that could be interpreted as violating the standard. The leader hoped to challenge the law through any resulting media attention. Despite the difficulty in enforcing the standard, the legal right changed some funding relationships and, for some organizations accepting Endowment grants, led to modifications of arts programs.

Moral rights are beliefs that one should be treated a certain way, not that one is legally required to be treated a certain way. Stakeholders who claim moral rights argue that certain treatment is appropriate or normatively correct. For example, the church group that wanted the exhibit of nude male statues removed had no legal basis for their demand, but felt they were morally justified in requesting this action. Parents who demanded that their children be exposed to art in the schoolroom, and insisted that a school's contracts with professional artists be honored despite budget cuts, called upon their children's moral right to receive cultural education.

Stakeholders may vary in their interests in an organization. For example, arts patrons may attend performances to satisfy a variety of interests: to enjoy the art, network socially, gain status as an art lover, etc. Depending on the nature of their interests, changes in organizational purposes or activities may not affect them. A transformation of a theater from one that welcomes amateur actors to one that only uses actors with Equity cards may not be of much consequence to a stakeholder who attends performances to talk to his friends during intermission. It would more deeply affect a stakeholder who enjoys the amateur quality of the theater.

This study has shown that differentiating problems according to whether they involve interest clashes or legitimacy concerns helps us predict responses. This analysis can be deepened by differentiating among types of rights and interests. Different responses may result, depending on which types are involved in a problem situation.

Understanding the basis for stakeholders' concerns may help leaders develop appropriate responses. Knowledge of legal rights may help leaders avoid legal actions pursued by stakeholders. Use of formal ethical codes and standards may help leaders identify stakeholders' moral rights and evaluate the importance of the rights. A variety of ethical codes are available to guide interactions with stakeholders (see for example, the National Charities Information Bureau, 1995, and INDEPENDENT SECTOR, 1991.) Identifying the conflicting interests in a problem situation may lead to more effective solutions. Persuading stakeholders of the benefits of an organization's activities, or adapting to provide more benefits, may increase stakeholders' perceptions of their interests in the organization and lead to greater stakeholder support.

Leaders may implicitly or explicitly prioritize their responsibilities as part of problem management. Business leaders rely on the common judgement that their first priority is to satisfy owners' interests in profits. Nonprofit leaders' priorities are less clear. There are no owners of nonprofit organizations claiming its profits as a return on their investments. Is nonprofit leaders' first priority to satisfy donors, patrons, board members or some other stakeholders? Guidelines from INDEPENDENT SECTOR (1991) argue that nonprofit leaders' first responsibility is to obey the law. Then they should consider their ethical responsibilities, and only then consider responsibilities to satisfy specific stakeholders' interests. This pyramid of responsibilities is similar to those proposed for the for-profit sector, except that at the base of the for-profit pyramid is the responsibility to make owner's profits, and at the top is the responsibility to be philanthropic and act as a good corporate citizen (see Carroll, 1991).

Additional studies are needed to see whether leaders are managing their relationships with stakeholders in a way that is consistent with the proposed pyramid of responsibilities. Are legal rights always honored over moral rights? Do moral rights override interests? Do leaders enact a consistent ranking of specific rights and interests? Are the interests of patrons or clients placed above other interests? Do leaders believe they have a responsibility to be good community citizens? How does this responsibility differ from a responsibility to deliver their mission? In addition to empirical studies to understand how leaders are weighing their responsibilities, ethical analyses of responsibility dilemmas are needed to provide moral guidance to leaders.

●Leaders' Network Perspective

Leaders shared the perspective that problems with particular stakeholders should not be treated as isolated incidents. Many leaders explicitly noted that poor management of a problem with one stakeholder might lead to new problems with other stakeholders. Even when this assumption was not explicitly stated, the leaders' actions generally reflected a strategic decision-making process that considered how responses to one stakeholder might affect other stakeholders. For example, directors knew that to satisfy some stakeholders' rights and interests, other stakeholders' rights and interests had to be sacrificed. Also, directors considered how satisfying some stakeholders could create new concerns and demands from the same or other stakeholders. Examination of only the rights and interests of the stakeholders directly involved in a problem situation fails to capture the broader context addressed by the problem-management strategies.

The directors' treatment of resource dependencies also reflect a network perspective. Leaders look beyond the resources they can attract from a specific stakeholder to judge how their relationship with that stakeholder might influence resource exchanges with other stakeholders. A dissatisfied stakeholder might publicly complain and convince other stakeholders to withdraw support. Calculations of resource dependencies that look only at the resources directly controlled by a stakeholder fail to capture the real power of stakeholders to influence organizational responses through a threat of lost resources from other stakeholders. The threat of losing a single source of resources may fail to motivate leaders to act to preserve that source. Leaders may believe that other sources of support can be found or expanded. Constructs capturing the larger context of resource dependencies better predict organizational actions than measures of resource importance attached to particular stakeholders without regard to their network character.

Stakeholder maps that address all the stakeholders and issues related to a problem can help leaders sort through the complexities of problem management. The maps can be designed to reflect stakeholders' rights and interests related to the problem, stakeholders' influence mechanisms, and communication and other links among the stakeholders. The maps may help leaders identify the current boundaries of a problem (which stakeholders are involved and what are their concerns) and how the problem might escalate (who may become involved and with what concerns.)

Applicability of the Problem Management Model to Other Fields and Sectors

This study has shown how legitimacy concerns and interest clashes are influential in explaining organizational actions. Organizations are not just marketplaces in which stakeholders' interests and desires for control are pursued. They also are embodiments of values

and norms fostered in their network of stakeholder relationships. Organizational leaders attempt to shape their external and internal environments to improve the environments' congruence with organizational interests, values, and norms. At the same time, a variety of institutional, economic, political, and technological forces push organizations to conform with stakeholders' interests, expectations, values, and norms. This study's typology of problems resulting from incongruence of organization and stakeholder, framework of strategic responses to the problems, and theories guiding predictions of responses are applicable to all types of organizations.

It is important to compare the management of problems with stakeholders across nonprofit fields. Leaders of social service, environmental advocacy, religious, and other types of nonprofit organizations may vary in the problem-management patterns they exhibit. Responsibilities and goals may differ across fields. For example, Jeavons (1994) argues that leaders of Christian service organizations have a distinct responsibility to provide opportunities to their employees for spiritual growth and to conduct their activities according to Christian ethics. New problem themes may emerge as different fields are examined. For example, the arts organizations I studied were not dependent on government contracts. If they had been, we may have seen more problems related to contracting tensions as described by Smith and Lipsky (1993).

The details of the applications may differ among nonprofit, government, and for-profit sectors. For example, business leaders may not be as willing to adapt in response to organizational legitimacy problems as leaders of nonprofit organizations. The proportion of legitimacy problems experienced by organizations in the nonprofit sector may be greater than in the for-profit sector because of the generally more values-based character of their work. In this study, the only predictor that could be interpreted as specifically addressing the nonprofit setting of the study was the mission threat variable. This variable could be applied to a for-profit setting to capture threats to a marketing niche, or to government to capture agency purposes and mandates. Without further testing of the frameworks and models in all sectors, we know little about how the specifics of problem management vary among the sectors.

The Practice of Artful Leadership

This book offers no checklist of procedures for effective leadership. There are no simple formulas to adopt. Instead, this book displays the variety of options available to leaders to manage relationships with stakeholders. The leaders' patterned behaviors and the recurring issues they face may be found in other leaders' experiences. By using the frameworks provided in the book to interpret problems and understand their responses, leaders may find previously unrecognized assumptions, values, norms, and interests guiding their actions. A

search for links among the problems may reveal common issues and management challenges. Thoughtful debate and consensus about the issues may offer guidance for resolving and preventing future problems related to the issues. Once common challenges are identified, leaders can build coherent sets of responses and evaluate their long-term benefit.

It is in the process of unlearning unsuccessful problem-management patterns and reinforcing successful ones that the frameworks provided in this book may be most helpful. Mission statements alone cannot provide adequate guidance for leaders. Leaders may find benefit in a shared understanding of the nature of relationships they desire with stakeholders and the behavioral options for managing those relationships.

APPENDIX A

STUDY METHODOLOGY

Much of the study presented in this book was designed and completed to partially fulfill requirements for a Ph.D. degree from the University of Michigan. Before collecting any data, I specified the hypotheses, data-collection methods, and measurement schemes. During my interviews with executive directors, new ideas arose related to my general interest in stakeholder management and the special challenges of running an arts organization. When time allowed, I explored these ideas in data gathering activities. This appendix first lays out the more formal methodology used for the study and then describes the coding of variables used in exploratory analyses.

Organization Sampling Procedure

I approached executive directors of 32 nonprofit organizations associated with the arts in the state of Michigan asking for their participation in the study. The initial approach was through a letter, which briefly explained the study and my request to gather information. Following the mailing of letters, I made telephone calls to the directors asking them to participate in the study and guaranteeing confidentiality. I scheduled interviews with 25 of the targeted organizations. Seven of the directors did not participate, for the following reasons. Two directors had been with their organizations less than two months and therefore did not have the knowledge needed to participate. Another director was recovering from a serious automobile accident and was physically unable to participate. The office of another organization was closed. Two other directors could not meet with me during the time period set for the interviews, although they offered to meet with me later. Another director refused to participate, stating that it was against organization policy to participate in research studies. Of the directors scheduled for interviews, one director repeatedly canceled appointments, and when she did not cancel was not in the office at the appointed times. She eventually asked to be dropped from the study for personal reasons. The final 24 sites in the

study satisfied my data needs and I made no effort to ask directors of additional organizations to participate in the study.

I chose the organizations to approach from a directory of nonprofit organizations provided by the state arts council. This directory was designed to be comprehensive and included organizations even if they did not receive council funding. Before selecting organizations, I excluded the three largest nonprofit arts organizations in the state from the sampling pool. These organizations' staff size, budgets, service area, and national reputation were far greater than those of the remainder of the organizations in the sampling pool. The resulting sampling pool was therefore representative of the most common types of nonprofit arts organizations operating in this country, the ones that are small to medium-sized with primarily a local, regional, or state service area.

I thought that the artistic domain of an organization might influence stakeholder management issues and practices. The organizational cultures and technical considerations associated with different kinds of artistic domains might attract different types of leaders and stakeholders, or encourage different types of leadership and stakeholder behaviors. Symphony orchestras, for example, are often stereotyped as being more conservative in style than theaters. As one director who was interviewed put it: "theater people like to joke among themselves 'we're theater people; what do you expect?' We're a loose bunch, not looseness in morals, although that, too, I suppose, but loose in the sense of a little flaky or artsy, whatever that means."

I wanted the selection process to be as random as possible but also wanted diversity among the organizations. Therefore, I stratified the sampling procedure by artistic arena, choosing eight organizations from each of four arenas to approach. The arts organizations in the final sample included four theaters, six symphony orchestras, six local arts councils, and eight arts centers or art museums.

Importance of Art Domain

Diversifying the sample allowed me to examine how appropriate it is to talk about nonprofit theaters, museums, arts councils, symphonies, and arts centers as members of the same population. Chi-square analyses showed that the artistic domain of the organizations in my sample is not significantly associated with use of any of the responses to problems. Therefore it appeared appropriate to combine the case problems from all four subgroups for my hypothesis tests. The subgroups also did not vary significantly in whether problems involved a mission threat or artistic quality issue.

However, the artistic domain did influence what types of problems were reported in the interviews. Table A.1 shows the breakdown of problem types by artistic domain. The subgroup including arts centers and museums, hereafter referred to simply as arts centers, reported significantly more interest clashes.

TABLE A.1

Differences in Problem Types by Artistic Domain Subgroups

Artistic Domain	Problem Type			
	Stakeholder Legitimacy	Organizational Legitimacy	Interest Clash	Row Total
Arts Councils (n=6)	10	7	9	26
Theaters (n=4)	8	6	3	17
Symphonies (n=6)	3	7	3	13
Arts Centers (n=8)	8	4	15	27
Column Total	29	24	30	83

Likelihood Ratio Chi-Square=11.43, df=6, significance=.07

Over 50 percent of the problems discussed by directors of arts centers involved interest clashes, compared to 23 percent of the problems discussed for symphonies, 17 percent for theaters, and 35 percent for arts councils. Perhaps this was due to the arts centers' much more general missions, which produced a greater variety of activities and outcomes that could potentially conflict with their stakeholders' activities and outcomes. Symphonies tended to report the greatest proportion of organizational legitimacy problems (54 percent). Of the four subgroups, the orchestras were going through the most significant transformations; they were becoming more professional in orientation and facing more fiscal constraints requiring program adjustments. These changes in orientation and practice were not always well-received by stakeholders. The changes were highly salient to directors and may have led them to discuss more organizational legitimacy problems than other types of problems. Theaters also experienced a large proportion of organizational legitimacy problems (35 percent), but experienced more stakeholder legitimacy problems (47 percent). Directors of arts councils were fairly balanced in the types of problems they reported (38 percent stakeholder legitimacy problems, 27 percent organizational legitimacy problems, and 35 percent interest clashes).

The symphony subgroup had organizations that were significantly older (see Table A.2) and more prestigious than the other subgroups. Many of the symphony directors reported that their organization was the premier cultural institution in their communities. However, as shown in Table A.1, their age and community standing did not protect them from experiencing organizational legitimacy problems. The arts councils and theaters generally are the youngest organizations in the study. Arts centers are equally split among the age groups.

TABLE A.2
Organization Age By Artistic Domain Subgroup

	Organization Age	
Artistic Domain	Under 25 Years	Over 25 Years
Arts Councils	6	0
Theaters	3	1
Symphony Orchestras	1	5
Arts Centers	4	4
Column Total	14	10

Likelihood Ratio Chi-Square=11.61, df=3, significance=.009

The revenue streams of the sample appear to be representative of those of the larger population of arts organizations. Table A.3 provides information on the revenue sources of the organizations in the sample. Salamon (1992) reported the following percentage breakdown of sources of 1989 income for nonprofit arts and entertainment organizations: Fees and other income, 48 percent; private giving, 32 percent; and government, 20 percent. The 24 organizations in my study had a similar average breakdown of sources of income: Fees and other income (earned plus other unearned income), 50 percent; private giving (corporate plus foundation plus other private), 31 percent; and government (state arts council plus other government), 17 percent.

It is revealing to look at differences in revenue streams among and within the subgroups. Looking at the averages for the subgroups, government plays a larger role in the funding of arts councils than in the other subgroups, and theaters draw more of their budget from earned income than the other subgroups. However, within each subgroup category, there is much variation in breakdown of revenue sources. Simple averages of percentages of income drawn from revenue streams fail to indicate this diversity. Each organization in the study faces a unique configuration of resource dependencies.

Collection of Data

I collected most of the data from interviews with executive directors. All interviews occurred at the organization sites and lasted from two to five hours. To facilitate coding, the interviews were taped and transcribed. In brief, I asked the directors to describe their organization's stakeholders, three recent problems the organization experienced with stakeholders, how the problems were handled, characteristics of their organization and its stakeholders, and history of the stakeholders' relationships with their organization. I did not constrain or guide the problems the directors chose to discuss, except to encourage them not to discuss problems they were currently managing. I did not mention my preconceived

TABLE A.3

Percentage Sources of Income of Organizations in Study

Revenues	Corporate		Earned Income		Foundation		Other Private		State Arts Council		Other Government		Other Unearned	
	Average	Range	Average	Range	Average	Range	Average	Range	Average	Range	Average	Range	Average	Range
All Organizations	8.6%	0-34%	40.6%	7-90%	9.1%	0-50%	13.9%	0-48%	8.6%	0-33%	8.7%	0-59%	9.3%	0-41%
Art Councils	14.3%	2-34%	25.4%	7-46%	9.9%	0-43%	5.5%	1-8%	10.3%	7-16%	24.1%	2-59%	9.6%	0-35%
Theaters	2.5%	0-7%	73%	58-90%	4.1%	0-16%	4.2%	0-10%	13.3%	4-33%	.3%	0-1%	1.5%	0-6%
Symphonies	12%	8-18%	38.2%	7-59%	6.4%	1-19%	16%	12-20%	6.5%	4-14%	4.2%	0-10%	12.2%	0-41%
Art Centers	4.6%	0-12%	35%	9-76%	14.4%	1-50%	23.7%	4-48%	6.6%	0-16%	6.4%	0-22%	10.9%	0-36%

frameworks or model to the directors. My questions were intentionally broad to encourage the directors to report their organizations' experiences and actions in their own words. The only exception was that I asked the directors to rate their stakeholders' importance.

All the quotations throughout the book are taken directly from the interview transcripts. I tried to choose the most representative statements possible. If some views or experiences were inconsistent with others, I tried to include contrasting statements. My study assumes that the individuals I interviewed described situations as they perceived them. If a director expressed any doubt about remembering a problem or response correctly, the problem was not included in the data set.

I attempt to balance the need to protect participants' identities with readers' need for contextual background to understand the problems and their management. Because of my promise of confidentiality, and the potential damage an organization might incur if it were linked to a problem that involved illegal activity or fraud, it is impossible for me to describe all the problems examined. Within confidentiality constraints, I present details of problems that vary in how flattering they are to the leaders and their organizations.

The directors discussed 83 problems in enough detail to be useful for the study. When time allowed, the directors discussed more than 3 problems. The average number of problems discussed by a director was 3.5. The range was 1 to 7 problems. The median number of problems discussed by directors was 3. Because I gathered 83 problems to use for the statistical analyses from only 24 organizations, I checked for independence problems using standard statistical procedures. Organization site was not significantly related to any of the variables used in the study.

In addition to the interview data, I used information from archival documents. The executive directors provided financial reports, minutes of board meetings, grant proposals to the Michigan Council for the Arts, and promotional materials. The proposals to the Michigan Council for the Arts were particularly useful for their detailed information on funding sources, board and staff background, board and staff composition and roles, organizational activities, and organizational mission and vision.

At the request of directors, I conducted additional interviews with other organizational members to confirm details of the problems and responses. I also made calls to directors during the coding phase to clarify ambiguous information from the interviews, or to collect information that I expected but did not find in the archival documents. Occasionally, the directors contacted me with updates on problems. This information was incorporated into the case materials.

Coding Procedures and Measurement of Variables

Using a coding form and standardized procedures, two coders read each interview transcript and independently coded the relevant variables. When the coders finished their independent

coding of a transcript, they met and compared results. When there were disagreements in the coding of a variable, the coders negotiated until they reached consensus. I coded organizational age and size from the archival documents and the stakeholder interaction variable from the interviews. With the organizational age, size, and stakeholder interaction variables, no interpretation of data was needed. The measurement was taken directly from available documents.

Problem Type

Problems were coded as one of three types: an organizational legitimacy problem, stakeholder legitimacy problem, or interest clash. The code was 1 for a problem that fit the type, 0 otherwise. No problem appeared to consist of a combination of types, or to shift types over time. The sample of 83 cases includes 24 organizational legitimacy problems, 29 stakeholder legitimacy problems and 30 interest clashes. Interrater agreement before negotiations was 88 percent for organizational legitimacy problems, 83 percent for stakeholder legitimacy problems, and 77 percent for interest clashes.

Responses to a Problem

The responses examined in the study are: (1) substantively adapt an organization; (2) compromise with a stakeholder; (3) change a stakeholder's understandings, values, or norms; (4) cut or weaken ties to a stakeholder; and (5) misrepresent or conceal information provided to a stakeholder. When a director reported use of a particular response for a problem, the code was a 1. If the director did not report use of the response, the code was a 0. Directors did not have to report that they personally implemented a response in order for it to be coded as a 1. It was sufficient for the directors to report that someone representing their organization had implemented the response.

A director could report use of more than one response for a problem. Directors reported the adapting response for 20 of the 83 problem cases. They reported compromising for 10 problems, and trying to change a stakeholder's understandings, values, or norms for 51 problems. Cutting or weakening ties was used for 20 problems. Misrepresenting or concealing information was reported for 22 problems. Interrater agreement before negotiation was 85 percent for adapting, 84 percent for compromising, 84 percent for trying to change a stakeholder, 97 percent for cutting or weakening ties, and 81 percent for misrepresenting.

Although more than one stakeholder was directly involved in a few of the problems, my statistical analyses were limited to examining an organization's response to only one stakeholder for each problem in the sample. I chose the stakeholder who required the most active response and ignored the organization's response to the other stakeholder(s) involved in the problem for the statistical analyses. However, the information regarding what happens when multiple stakeholders are involved in a problem was carefully considered in elaborating the findings beyond what the statistical analyses could show.

Stakeholder's Importance

During the interviews, executive directors used a scale from 1 to 5 to rank the importance to their organization of each stakeholder involved in a problem, with 5 being the highest ranking. The directors explained the rationale behind their rankings and described the resources exchanged by their organizations and the stakeholders involved in problems. For eight of the problem cases, directors did not provide a ranking. In these cases, the coders gave rankings based on the description of the resources exchanged and their importance. The mean for the importance variable was 2.5 with a standard deviation of 1.42.

Stakeholder's Decision-Making Authority in an Organization

Stakeholder decision-making authority was coded from the interview transcripts using a 1 to 5 scale. A 5 was coded for a stakeholder with very significant authority to make decisions, such as a chairperson of an organization's board of directors. A 1 was coded for a stakeholder with no decision-making authority within an organization. This variable skewed towards stakeholders with little decision-making authority. The mean was 1.3 with a standard deviation of 1.36. Stakeholders without any decision-making authority within an organization (coded as 1) were involved in 42 percent of the problems. The sample of problems includes a fairly equal split between internal and external stakeholders. The raters agreed on the coding of 50 percent of the total cases and 72 percent of the cases if unclear cases are excluded. For 90 percent of the cases, the raters had no more than a one-point difference in their ratings before negotiation.

Stakeholder's Access to Uncontrolled Information

To measure this variable, coders looked at the interview transcripts to determine a director's interpretation of the quality and quantity of uncontrolled information that was available to a stakeholder. The coders used a 1 to 5 scale, with 5 indicating that a stakeholder involved in a problem was interpreted to have very good uncontrolled information. The mean for the variable was 2.5 with a standard deviation of 1.34. Interrater agreement was 66 percent before negotiation, 74 percent if cases coded as unclear are excluded.

Stakeholder's Interaction with Organizational Workers

I measured the stakeholder's interaction with organizational workers using interview data For a problem-interaction measure, I coded who dealt with a stakeholder during the problem-response process. The executive director responded to the problem in 72 out of the 83 cases. In 56 cases, both the director and board responded. There were no cases in which a board interacted with a stakeholder during the problem stage and the director did not. I coded problem interaction as a 3 if both a director and board of directors interacted with a

stakeholder about a problem. I coded a 2 if only the director interacted with the stakeholder during this period. I coded the measure as a 1 if another organizational worker besides the director interacted with the stakeholder about the problem, or if nobody in the organization interacted with the stakeholder about the problem (11 cases). For a routine interaction measure, the code was a 3 if there was frequent routine interaction with the director or board members, a 2 if there was a medium level of routine interaction with any type of organizational worker, and a 1 if there was little routine interaction with any type of organizational worker. There were no cases in which there was frequent interaction with organizational workers other than the director or board members. I identified 21 cases where the routine interaction was frequent, 44 cases where the routine interaction was infrequent, and 18 cases in the middle. I added these two measures to determine the value of the stakeholder interaction variable. Values ranged from 2 to 6, with a mean of 4.2 and a standard deviation of 1.35.

Threat to Organization's Mission

The interview transcripts revealed whether leaders believed a problem involved a threat to their organization's mission. The mission threat variable was coded as a 1 if a stakeholder threatened the mission and 0 otherwise. In 20 out of the 83 problem cases, a stakeholder threatened the mission. In 7 cases, a stakeholder explicitly challenged the mission, suggesting or demanding a mission change. In the other 13 cases, leaders believed a stakeholder was undermining the mission by working at cross-purposes or draining resources needed to fulfill the mission. Interrater agreement was 100 percent.

Artistic Quality Concerns

Cases involving artistic quality concerns were identified from the transcripts. If artistic quality was an issue in a problem, the code was a 1; otherwise it was a 0. There were 12 cases involving artistic quality concerns. Interrater agreement was 97 percent before negotiation.

Problem Seriousness

The interview transcripts provided the information for coding problem seriousness. Coders looked at how a director thought a problem actually did and potentially could have threatened an organization. The more layers of an organization that a director thought were or could be affected, and the more a problem was interpreted to be of a strategic versus operational nature, the higher the ranking of seriousness of the problem. The scale was from 1 to 3, with 3 indicating the most serious problems. There were 35 problems of great seriousness, 39 problems of little seriousness, and 9 problems in the middle.

Organization Age

I calculated organization age from the year of founding reported in proposals to the Michigan Council for the Arts or from promotional brochures. Age ranged from 7 to 88 years. The mean age was 33 years with a standard deviation of 24.33. For regression and correlational analyses, I use the log of the age.

For cross-tabulations, I use a categorical variable to capture age. I coded all organizations under 25 years of age as a 1 and all organizations over 25 as a 2. The data showed a natural break in ages at the 25-year mark. Also, my dividing the cases at the 25-year mark had the result that all the organizations still run by their founders belonged to the younger age group and most of the organizations that had survived a successor belonged to the older age group. The literature traditionally asserts that an executive-succession event is a critical time for an organization and that new executives tend to be chosen for their ability to cope with critical contingencies (Pfeffer & Salancik, 1978). Therefore, the 25-year break captures the potentially greater competencies of executive directors who have succeeded previous directors.

Organization Size

I measured organizational size from number of paid administrative staff members, full and part-time, and number of volunteer work hours reported in proposals to the Michigan Council for the Arts and in strategic plans. Number of full or part-time paid staff members ranged from 1 to 29, with a mean of 9 and a standard deviation of 7.97. I logged size for the regression analyses and correlations. For cross-tabulations, I used a 1 to 3 scale, with the largest organizations coded as a 3. There were 34 problems in the sample from smaller organizations, 21 from mid-sized organizations, and 28 from larger organizations. The mean was 1.93. The standard deviation was .87.

I did not measure the number of artists working for an organization for several reasons. One, the number was highly correlated with type of organization. Symphonies and theaters, for example, always had more artists working for them than art councils. Also, the number of artists was theoretically irrelevant because artistic and administrative tasks were distinct in the organizations in my sample. Artists had little involvement in the management of problems with stakeholders, unless the stakeholders were well-connected to artistic tasks. Symphony musicians, for example, had little interaction with funders or the media. The exceptions were when the artists themselves were the stakeholders involved in a problem with an organization.

Coding of Variables Used in Exploratory Analyses

During the interviews, many directors discussed the consequences of their actions to resolve a problem. Although I had no hypotheses regarding which responses would be more or less effective, I was interested in seeing whether some patterns regarding consequences of responses could be found. Therefore, I asked the coders to rate the organization's satisfaction with a response as reported by the directors and the directors' sense of the stakeholders' satisfaction with the response. Although the satisfaction measure may reflect a variety of underlying dimensions, the coders made no attempt to distinguish among different types of satisfaction.

Organization Satisfaction

The organization satisfaction variable was coded on a 1 to 5 scale using the interview transcripts. A coding of a 5 indicated that an organization's leaders were very satisfied with the response and its consequences. Interrater agreement was 70 percent before negotiation. Complete consensus was reached. The mean was 2.15 with a standard deviation of 1.44. There was one case with a missing value.

Stakeholder Satisfaction

The stakeholder satisfaction variable was coded on a 1 to 5 scale, with 5 indicating that a director believed that a stakeholder was very satisfied with an organization's response to a problem. Interrater agreement was 80 percent and consensus was reached with negotiation. The mean was 1.85 with a standard deviation of 1.62. There were five cases with missing data.

Types of Stakeholders

Some of the analyses consider types of stakeholders. A variety of categories of stakeholders were constructed for the analyses. An internal stakeholder category includes the following subcategories: board member, artistic staff, administrative staff, artistic volunteer, and administrative volunteer. External stakeholders includes other arts organizations, patrons, funders, media, other artists, business contacts, and other. Table 1.2 provides the frequencies of problems involving these types of stakeholders.

Study Limitations

This book has extended the research pursued for my dissertation, combining new exploratory analyses with variations of the original tests of hypotheses. To protect confidentiality, this study could not contrast personality and background characteristics of leaders. We know

that personality differences affect individuals' responses to conflict situations (Blake & Mouton, 1964; Hambrick & Finckelstein, 1987). Additional work incorporating characteristics of leaders into the stakeholder management model may be fruitful.

The findings are based on the experiences of 24 small to medium-sized arts organizations. It is unclear how generalizable the findings are to the much larger arts organizations sharing the nonprofit arts sector, or to other types of organizations, nonprofit and other. Additional work providing comparisons with other institutional contexts would add to our understanding of the generalizability of the specific features of the stakeholder management process described in this book. For example, we may find that for-profit organizations do not respond as aggressively as nonprofit organizations to legitimacy problems. They may be more likely to use adaptation or cutting ties responses for interest clashes.

This study focuses on directors' interpretations of their organizations' experiences with problems with stakeholders. It therefore offers a one-sided view. Social realities are subjective, and I would be remiss if I did not emphasize the perspective adopted in this book. Different dynamics of the stakeholder management process may be discovered by investigating stakeholders' perspectives and their responses.

APPENDIX B

TABLE B.1

Correlations of Responses with Predictors Showing Two-tailed Significance Levels

			Responses		
Predictors	Adapt Organization	Compromise	Change Stakeholder	Cut/Weaken Ties	Misrepresent
Stakeholder Importance	.263 p = .016	-.011 p = .921	.305 p = .005	-.277 p = .011	-.134 p = .226
Stakeholder Decision Authority	.062 p = .577	-.165 p = .137	.012 p = .916	.146 p = .189	.109 p = .329
Organization Age (Logged)	-.091 p = .413	-.089 p = .426	-.050 p = .656	-.211 p = .055	-.008 p = .945
Organization Size (Logged)	-.132 p = .234	.029 p = .795	-.072 p = .520	-.235 p = .032	.019 p = .866
Mission Threat	-.186 p = .093	.138 p = .215	.041 p = .712	.078 p = .485	-.019 p = .863
Problem Seriousness	.178 p = .107	.215 p = .051	.143 p = .196	.148 p = .181	.118 p = .290
Artistic Quality Issue	-.152 p = .171	.164 p = .140	-.097 p = .385	-.071 p = .521	.297 p = .007
Organization Legitimacy Problem	.076 p = .497	.009 p = .937	.014 p = .901	-.235 p = .032	.099 p = .375
Stakeholder Legitimacy Problem	-.177 p = .110	.039 p = .724	-.095 p = .396	.414 p = .000	.075 p = .499
Interest Clash	.104 p = .350	-.047 p = .671	.081 p = .468	-.189 p = .086	-.168 p = .130

APPENDIX C

LOGISTIC REGRESSIONS SHOWING SIGNIFICANT EFFECTS OF AGE OR SIZE

TABLE C.1

Test of Model of Adapting Omitting Size Variable

Variables	B	Standard Error	Wald Statistic	Significance
Stakeholder Resource Importance	.455	.255	3.195	.07
Stakeholder Decision Authority	.116	.236	.240	.62
Organization Age	2.250	1.207	3.479	.06
Artistic Quality Issue	-1.033	1.223	.714	.40
Problem Seriousness	.321	.344	.867	.35
Problem Type	4.563	.10		
Organization Legitimacy	.896	.482	3.447	.06
Stakeholder Legitimacy	-1.019	.505	4.070	.04
Constant	3.091	2.449	1.593	.21

	Chi-Square	df	Significance
-2 Log Likelihood	73.191		n.s.
Model Chi-Square	18.472	8	.018
Model Correctly Classified	75.90 percent of cases		
N=83			

TABLE C.2
Test of Model of Adapting Omitting Age Variable

Variables	B	Standard Error	Wald Statistic	Significance
Stakeholder Resource Importance	.480	.256	3.501	.06
Stakeholder Decision Authority	-.014	.220	.004	.95
Organization Size	-1.607	.799	4.050	.04
Mission Threat	-1.527	.901	2.871	.09
Artistic Quality Issue	-1.399	1.211	1.335	.25
Problem Seriousness	.425	.346	1.508	.22
Problem Type	3.625	.16		
Organization Legitimacy	.746	.457	2.665	.10
Stakeholder Legitimacy	-.846	.477	3.148	.08
Constant	.547	1.483	.136	.71

	Chi-Square	df	Significance
-2 Log Likelihood	72.606		n.s.
Model Chi-Square	19.058	8	.015
Model Correctly Classified	75.90 percent of cases		

N=83

TABLE C.3
Test Model of Cutting or Weakening Ties Omitting Age Variable

Variables	B	Standard Error	Wald Statistic	Significance
Stakeholder Resource Importance	- 1.333	.431	9.584	.002
Stakeholder Decision Authority	.769	.381	4.061	.04
Organization Size	-1.595	.909	3.078	.08
Mission Threat	1.738	.985	3.114	.08
Artistic Quality Issue	-1.840	1.232	2.230	.14
Problem Seriousness	1.327	.486	7.446	.006
Problem Type	11.914	.003		
Organization Legitimacy	-.903	.689	1.715	.19
Stakeholder Legitimacy	.2.317	.673	11.861	.001
Constant	-4.542	2.053	4.896	.03

	Chi-Square	df	Significance
-2 Log Likelihood	48.059		n.s.
Model Chi-Square	43.604	8	.000
Model Correctly Classified	89.16 percent of cases		

N=83

REFERENCES

Abelson, R.P. "Script processing in attitude formation and decision-making." In J.S. Carroll & J.W. Payne (Eds.) *Cognition and Social Behavior*. Hillsdale, NJ: Erlbaum, 1976.

Adams, C.T. and F.D. Perlmutter. "Leadership in hard times: Are nonprofits well-served?" *Nonprofit and Voluntary Sector Quarterly*, 1995, 24, 253-262.

Aldrich, H. and E.R. Auster. "Even dwarfs started small: Liabilities of age and size and their strategic implications." *Research in Organizational Behavior*, 1986, 8, 165-198.

Altman, J.A. and E. Petkus, Jr. "Toward a stakeholder-based policy process: An application of the social marketing perspective to environmental policy development." *Policy Sciences*, 1994, 27, 37-51.

Ashforth, B.E. and B.W. Gibbs. "The double-edge of organizational legitimation." *Organization Science*, 1990, 1, 177-194.

Astley, W.G. and P.S. Sachdeva. "Structural sources of intraorganizational power: A theoretical synthesis." *Academy of Management Review*, 1984, 9, 104-113.

Banfield, E.C. *The Democratic Muse: Visual Arts and the Public Interest*. New York: Basic Books, 1984.

Baron, R.A. "Attributions and organizational conflict: The mediating role of apparent sincerity." *Organizational Behavior and Human Decision Processes*, 1988, 41, 111-127.

Bielefeld, W. "What affects nonprofit survival?" *Nonprofit Management & Leadership*, 1994, 5, 19-36.

Benoit, W.L. *Accounts, Excuses, and Apologies: A Theory of Image Restoration Strategies*, Albany: State University of New York Press, 1995

Blake, R.R. and J.S. Mouton. *Building a Dynamic Corporation through Grid Organizational Development*. Reading, MA: Addison-Wesley, 1969.

Blau, J.R. *The Shape of Culture*. Cambridge: Cambridge University Press, 1989.

Bozeman, B.L. and J. Straussman. "Organization 'publicness' and resource process." In R. Hall and R.E. Quinn (Eds.) *Organization Theory and Public Policy*. Newbury Park, CA: Sage, 1983.

Brinckerhoff, P.C. *Mission-Based Management*. Dillon, Colorado: Alpine Guild, Inc., 1994.

Brunsson, N. *The Organization of Hypocrisy: Talk, Decisions and Actions in Organizations*. New York: John Wiley & Sons, 1989.

Bryson, J.M. and B.C. Crosby. *Leadership for the Common Good*. San Francisco: Jossey-Bass Publishers, 1992.

Carroll, A.B. *Business and Society: Ethics and Stakeholder Management*. Cincinnati: Southwestern College Publishing, 1996.

Carroll, A.B. "The pyramid of corporate social responsibility: Toward the moral management of organizational stakeholders." *Business Horizons*, July-August, 1991.

References

Chandler, A.D. *Strategy and Structure*. Boston: MIT Press, 1962.

Cyert, R.M. and J.G. March. *A Behavioral Theory of the Firm*. Englewood Cliffs: Prentice-Hall, 1963.

Daft, R. and Weick, K.E. "Toward a model of organizations as interpretation systems." *Academy of Management Review*, 1984, 9, 284-295.

DiMaggio, P. "Interest and agency in institutional theory." In L.G. Zucker (Ed.) *Institutional Patterns and Organizations: Culture and Environment*. Cambridge: Ballinger Publishing Company, 1988.

DiMaggio, P.J. *Nonprofit Enterprise in the Arts: Studies in Mission and Constraint*. New York: Oxford University Press, 1986.

Dowling, J. and Pfeffer, J. "Organizational legitimacy: Social values and organizational behavior." *Pacific Sociological Review*, 1975, 18, 122-136.

Drucker P.F. *Managing the Non-profit Organization: Practices and Principles*. New York: Harper Collins, 1990.

Enz, C.A. "The role of value congruity in intraorganizational power." *Administrative Science Quarterly*, 1988, 33, 284-304.

Fisher, R. and W. Ury. *Getting to Yes*. New York: Penguin Books, 1981.

Freeman, R.E. *Strategic Management: A Stakeholder Approach*. Boston: Pitman, 1984.

Freedman, M.R. "The elusive promise of management cooperation in the performing arts." In P.J. DiMaggio (Ed.), *Nonprofit Enterprise in the Arts*. New York: Oxford University Press, 1986.

Frohnmayer, J. *Leaving Town Alive: Confessions of an Arts Warrior*. Houghton Mifflin Company: Boston, 1993.

Frost, F.A. "The use of stakeholder analysis to understand ethical and moral issues in the primary resource sector." *Journal of Business Ethics*, 1995, 14, 653-661.

Gandossy, R.P. *Bad Business: The OPM Scandal and the Seduction of the Establishment*. New York: Basic Books, 1985.

Gioia, D.A. and P.P. Poole. "Scripts in organizational behavior." *Academy of Management Review*, 1984, 9, 449-459.

Goldner F.H., Ritti, R.R. and T.P. Ference. "The production of cynical knowledge in organizations." *American Sociological Review*, 1977, 42, 539-551.

Gray, B., M.G. Bougon, and A. Donnellon. "Organizations as constructions and deconstructions of meaning." *Journal of Management*, 1985, 11, 83-98.

Gronbjerg, K.A. *Understanding Nonprofit Funding: Managing Revenues in Social Services and Community Development Organizations*. Jossey-Bass Publishers: San Francisco, 1993.

Hall, H. "United Way's comeback." *The Chronicle of Philanthropy*, 1995, (January 26) 19-20.

Hall, P.D. *Inventing the Nonprofit Sector and Other Essays on Philanthropy, Voluntarism, and Nonprofit Organizations*. Baltimore, MD: Johns Hopkins University Press, 1992.

Hambrick, D.C. and S. Finkelstein. "Managerial discretion: A bridge between polar views of organizational outcomes." In L.L. Cummings and B.M. Staw (Eds.) *Research in Organizational Behavior*, 1987, 9, 369-406.

Hannan, M.T. and J. Freeman. *Organizational Ecology.* Cambridge: Harvard University Press, 1989.

Hannan, M.T. and J. Freeman. "Structural inertia and organizational change." *American Sociological Review*, 1984, 49, 149-164.

Heimovics, R.D. and R.D. Herman. "Responsibility for critical events in nonprofit organizations." *Nonprofit and Voluntary Sector Quarterly*, 1990, 19, 59-72.

Heimovics, R.D., R.D. Herman, and C.L. Jurkiewicz. "The political dimension of effective nonprofit executive leadership." *Nonprofit Management & Leadership*, 1995, 5, 233-248.

Herman, R.D., and R.D.Heimovics. "Critical events in the management of nonprofit organizations." *Nonprofit and Voluntary Sector Quarterly*, 1989, 18, 119-132.

Hickson, D.J., C.R. Hinings, C.A. Lee, R.E. Schneck, and J.M. Pennings. "A strategic contingencies theory of intraorganizational power." *Administrative Science Quarterly*, 1971, 16, 216-229.

Hinings, B. and R. Greenwood. "The normative prescription of organizations." In L.G. Zucker (Ed.) *Institutional Patterns and Organizations: Culture and Environment.* Cambridge: Ballinger Publishing Company.

Hodgkin, C. "Rejecting the lure of the corporate model." *Nonprofit Management & Leadership*, 1993, 3, 415-428.

Homans, G. *The Human Group.* New York: Harcourt Brace, 1950.

INDEPENDENT SECTOR. *Ethics and the Nation's Voluntary and Philanthropic Community: Obedience to the Unenforceable.* Washington, D.C. 1991.

Jackall, R. *Moral Mazes: The World of Corporate Managers.* New York: Oxford University Press, 1988.

Janis, I.L. *Groupthink: Psychological Studies of Policy Decisions and Fiascoes*, 2nd Ed. Boston: Houghton Mifflin.

Jackson, S.E. and J.E. Dutton. "Discerning threats and opportunities." *Administrative Science Quarterly*, 1988, 33, 370-387.

Jeavons, T.H. "Stewardship revisited: Secular and sacred views of governance and management." *Nonprofit and Voluntary Sector Quarterly*, 1994, 23, 107-122.

Kamens, D.H. "Legitimating myths and educational organization: The relationship between organizational ideology and formal structure." *American Sociological Review*, 1977, 42, 208-219.

Kanter, D.L. and P.H. Mirvis. *The Cynical Americans: Living and Working in an Age of Discontent and Disillusion.* San Francisco: Jossey-Bass Publishers, 1989.

Kanter, R.M. *Commitment and Community: Communes and Utopias in Sociological Perspective.* Cambridge: Harvard University Press, 1972.

Kanter, R.M. and D.V. Summers. "Doing well while doing good: Dilemmas of performance measurement in nonprofit organizations and the need for a multiple-constituency approach." In W.W. Powell (Ed.) *The Nonprofit Sector: A Research Handbook.* New Haven: Yale University Press, 1987.

References

Klausen, K.K. "On the malfunction of the generic approach in small voluntary associations." *Nonprofit Management & Leadership*, 1995, 5, 275-290.

Koteen, J. *Strategic Management in Public and Nonprofit Organizations*. New York: Praeger, 1989.

Lauffer, A. and S. Gorodezky. *Volunteers*. London: Sage, 1977

Meyer, J. and B. Rowan. "Institutionalized organizations: Formal structure as myth and ceremony." *American Journal of Sociology*, 1977, 83, 340-363.

Meyer, J.W., W.R. Scott and T.E. Deal. "Institutional and technical sources of organizational structure: Explaining the structure of educational organizations." In H.D. Stein (Ed.) *Organization and Human Services*. Philadelphia: Temple University Press, 1981.

Meyer, J.W. and R. Scott. *Organizational Environments: Ritual and Rationality*. Beverly Hills: Sage, 1983.

Miller, L.E., E.J. Kruger and M.S. Gass. "Nonprofit boards and perceptions of funding." *Nonprofit Management & Leadership*, 1994, 5, 3-18.

Milliken, F. "Perceiving and interpreting environmental change: An examination of college administrators' interpretation of changing demographics." *Academy of Management Journal*, 1990, 33, 42-63.

Mintzberg, H. "Crafting strategy." *Harvard Business Review*, July-August, 1987.

Mintzberg, H. *Power In and Around Organizations*. Englewood Cliffs, NJ: Prentice-Hall, Inc., 1983.

Mintzberg, H. and J.B. Quinn. *The Strategy Process: Concepts and Contexts*. Englewood Cliffs, NJ: Prentice Hall, 1992.

Morgan, G. *Images of Organizations*. Beverly Hills: Sage, 1986.

Morgan, G. "Rethinking corporate strategy: A cybernetic perspective." *Human Relations*, 1983, 36, 4, 345-360.

Mueller, C. *The Politics of Communication*. London: Oxford University Press, 1973.

National Charities Information Bureau. "NCIB standards in philanthropy." *Wise Giving Guide*. June 1995.

Nelson, R.E. "The strength of strong ties: Social networks and intergroup conflict in organizations." *Academy of Management Journal*, 1989, 32, 377-401.

O'Connell, B. *The Board Member's Book*, 2nd Ed. New York: The Foundation Center, 1993.

O'Neill, M. *The Third America: The Emergence of the Nonprofit Sector in the United States*. San Francisco: Jossey-Bass Publishers, 1989.

Oliver, C. "Strategic responses to institutional processes." *Academy of Management Review*, 1991, 16, 145-179.

Oster, S.M. *Strategic Management for Nonprofit Organizations: Theory and Cases*. New York: Oxford University Press, 1995.

Ostrowski, M.R. "Nonprofit boards of directors." In D.L. Gies, J.S. Ott, and J.M. Shafritz (Eds.) *The Nonprofit Organization: Essential Readings*. Pacific Grove, CA: Brooks/Cole Publishing Company, 1990.

Parsons, T. *Structure and Process in Modern Societies*. New York: Free Press, 1960.

Pfeffer, J. "Management as symbolic action: The creation and maintenance of organizational paradigms." In L.L. Cummings and B.M. Staw (Eds.) *Research in Organizational Behavior*, 1981, 3, 1-52.

Pfeffer, J. and Salancik, G.R. *The External Control of Organizations: A Resource Dependence Perspective*. New York: Harper and Row, 1978.

Rawls, J. *A Theory of Justice*. Cambridge: Harvard University Press, 1971.

Salamon, L.M. *America's Nonprofit Sector: A Primer*. The Foundation Center: New York, 1992.

Salancik, G.R. "Commitment and the control of organizational behavior and belief." In B.M. Staw and G.R. Salancik (Eds.) *New Directions in Organizational Behavior*. Chicago: St. Clair Press, 1977.

Savage, G.T., T.W. Nix, C.J. Whitehead, and J.D. Blair. "Strategies for assessing and managing organizational stakeholders." *Academy of Management Executive*, 1991, 5, 61-75.

Scott, W.R. *Organizations: Rational, Natural, and Open Systems*. 2nd Ed. Englewood Cliffs: Prentice-Hall, 1987.

Scott, M.H. and S.M. Lyman. "Accounts." *American Sociological Review*, 1968, 33, 46-62.

Selznick, P. *TVA and the Grass Roots: A Study in the Sociology of Formal Organization*. New York: Harper Torchbooks, 1966.

Simon, H.A. *Administrative Behavior*. 2nd Ed. New York: Free Press, 1965.

Simon, H.A. *The New Science of Management Decision*. New York: Harper, 1960.

Singh, J.V., D.J. Tucker, and R.J. House. "Organizational legitimacy and the liability of newness." *Administrative Science Quarterly, 1986, 31, 171-193.*

Smith, Bucklin, & Associates. *The Complete Guide to Nonprofit Management*. New York: John Wiley & Sons, Inc., 1994.

Smith, D.H. *Entrusted: The Moral Responsibilities of Trusteeship*. Bloomington: Indiana University Press, 1995.

Smith, D.H. and C. Shen. "Factors characterizing the most effective nonprofits managed by volunteers." *Nonprofit Management & Leadership*, 1996, 6, 271-290.

Smith, S.R., and M. Lipsky. *Nonprofits for Hire: The Welfare State in the Age of Contracting*, Cambridge: Harvard University Press, 1993.

Stapleton, D.H. "Pursuit of mission: The rise and fall of elite nonprofit leadership." *Nonprofit Management & Leadership*, 1995, 5, 393-409.

Starbuck, W.H. "Congealing oil: Inventing ideologies to justify acting ideologies out." *Journal of Management Studies, 1982, 19, 3-27.*

Stinchcombe, A.L. "Social structure and organizations." In J.G. March (Ed.) *Handbook of Organizations*. Chicago: Rand McNally, 1965.

Stone, M.M. and W. Crittenden. "A guide to journal articles on strategic management in nonprofit organizations: 1977 to 1992." *Nonprofit Management & Leadership*, 1993, 4, 141-155.

Sukel, W.M. "Third sector organizations: A needed look at the artistic-cultural organization." *Academy of Management Review*, 1978, 3, 348-54.

References

Sutton, R.I. and Callahan, A.L. "The stigma of bankruptcy: Spoiled organizational image and its management." *Academy of Management Journal,* 1987, 30, 405-436.

Sutton, R.I. and R.M. Kramer. "Transforming failure into success: Impression management, the Reagan Administration, and the Iceland Arms Control talks." In R.L. Kahn and M.W. Zald (Eds.) *International Cooperation and Conflict: Perspectives from Organizational Theory.* San Francisco: Jossey-Bass Publishers, 1990.

Swanson, D.L. "Addressing a theoretical problem by reorienting the corporate social performance model." *Academy of Management Journal,* 1995, 20, 43-64.

Thomas, J.B., S.M. Clark, and D.A. Gioia. "Strategic sensemaking and organizational performance: Linkages among scanning, interpretation, action, and outcomes." *Academy of Management Journal,* 1993, 36, 239-270.

Thomas, K.W. "Conflict and conflict management" in M.D. Dunnete (Ed.) *Handbook of Industrial and Organizational Psychology.* Chicago: Rand-McNally, 1976.

Thompson, J.D. *Organizations in Action.* New York: McGraw-Hill, 1967.

Tschirhart, M. *The Management of Problems with Stakeholders,* doctoral dissertation, University of Michigan, 1993

Van Til, J. "Nonprofit organizations and social institutions." In R.D. Herman and Associates (Eds.) *The Jossey-Bass Handbook of Nonprofit Leadership and Management.* San Francisco: Jossey-Bass Publishers, 1994.

Weber, M. *The Theory of Social and Economic Organization,* translated and edited by A.M. Henderson and T. Parsons. New York: Oxford University Press, 1947.

Williamson, O. *Markets and Hierarchy.* New York: Free Press, 1975.

Zald, M.N. and P. Denton. "From evangelism to general service: The transformation of the YMCA." *Administrative Science Quarterly.* 1963, 8: 214-234.

INDEX

Index

Index

ABOUT THE AUTHOR

Mary Tschirhart is an assistant professor of policy and administration at the School of Public and Environmental Affairs at Indiana University in Bloomington. She also is an adjunct faculty member of the Indiana University Center on Philanthropy. She teaches courses on management skills, nonprofit organizations, fund development, and organizational behavior and theory. She writes on the relationships of organizations to their environments. Her particular interest is in how nonprofit organizations attempt to change individuals' attitudes and behaviors.

She earned a B.A. in philosophy from Michigan State University, M.B.A. in arts administration from the State University of New York-Binghamton, and Ph.D. in organizational behavior and human resource management from the University of Michigan. Before pursuing her doctorate, Professor Tschirhart was the executive director of Young Audiences of Michigan, a state chapter of a national nonprofit organization bringing professional artists into schools. She currently serves on the boards of two nonprofit organizations and provides consulting services to nonprofit and public agencies.